Wax and Paper

Workshop

Techniques For
Combining Encaustic Paint
And Handmade Paper

CONTENTS

INTRODUCTION [5]

IN THE PAPER STUDIO [6]

IN THE ENCAUSTIC STUDIO [50]

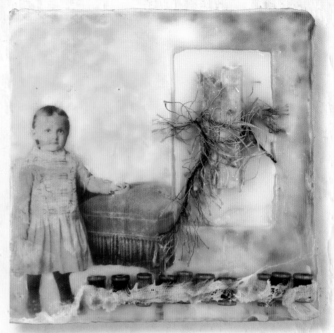

GALLERY: PLACE IN TIME
(watercolor, color transfer, embedding)

GALLERY OF ARTISTS [106]

Have a smartphone with a QR code reader? Throughout the book you will find QR codes like this one—scan them for access to related bonus content and tutorials!

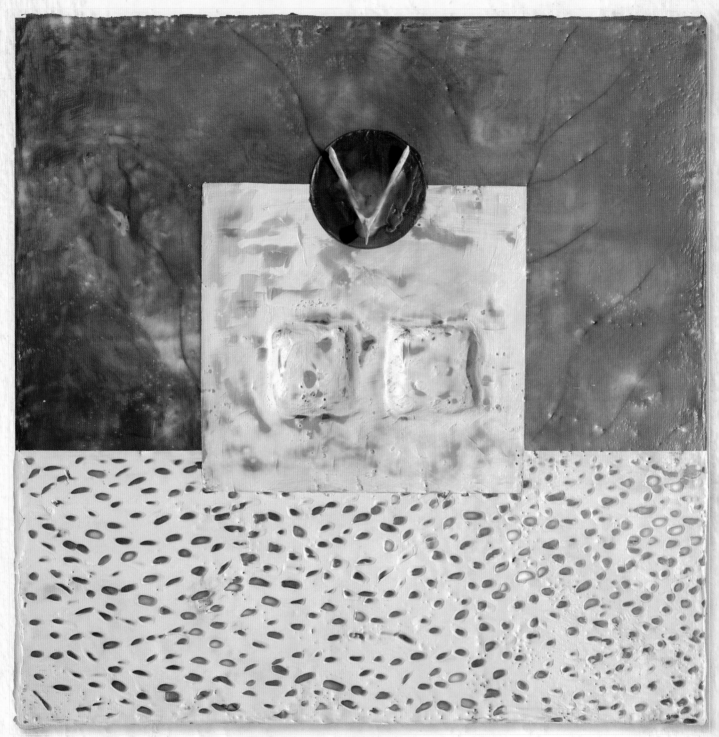

GALLERY: SEARCHING FOR BALANCE

I began marking this wet piece of paper with ink. You can see that under painting through the top half of the work. The texture was created using a metal dental tool heated on the pallet. I liked the way the marks of the tool revealed the original layer of paint.

(cotton, abaca, beeswax, resin, pigment)

INTRODUCTION

Almost everyone who works in wax has come to this medium through another discipline. Today's leading encaustic painters began their careers as printmakers or sculptors or mixed media artists. Most artists come to encaustic painting because the wax adds an exciting dimension to their work. Some artists fully embrace encaustic and continue to explore and expand their tool bag, while others move back to their original modalities, using wax as one ingredient in the process. I came to wax through papermaking.

At the beginning of my visual art career, I was a fiber artist working with silks, dyes and stitchery on fabric. In the early 1990s, while taking some post-graduate courses at the Southwest School of Art, I discovered paper and began my lifelong love affair with pulp. I am fascinated with the versatility of paper. It can be formed, cast, sculpted, pulp painted, collaged, embossed, blown, stretched and used in many other ways I have yet to discover.

From the beginning, I was less interested in creating sheets of paper and more concerned with working larger and more sculptural. I first explored paper as a bas-relief, finding ways to move beyond the typical rectangular or square format and into interesting shapes with several dimensional layers. It was only much later that I began to think of these cast paper works as canvases for paint. I had tried a variety of ways to add color over the years but hadn't found anything that provided the brilliance of the silk dyes that were part of my surface design experience.

A few years ago, I was lunching with a friend, sharing my frustration in working with acrylic paint on paper. She advised me to try wax. I was intrigued, having never experienced encaustic painting. I couldn't fathom how one could paint with molten beeswax. After some research and a lot of trial and error (mostly error) I came to believe that wax is the perfect partner for paper. Surprisingly, for me the lure of wax has become as strong as my attraction to paper. My work today is about the exploration of these two organic mediums: paper and wax. The encaustic process of painting and scraping, melting and molding the wax allows me to be inventive in a way that is both immediate and spontaneous. The process of making my own paper substrate opens limitless doors for experimentation. In these two media, I believe I will have enough material to explore for the rest of my life.

HOW TO USE THIS BOOK

Painting with wax is immediate; paper takes time to dry. For that reason, I've set up the book into two sections: In the Paper Studio and In the Encaustic Studio. Some readers might like to set up a paper studio and then go through each of the demonstrations of making paper, cutting supports, and wrapping and casting paper to amass a whole body of delicious canvases in preparation for the wax. The wax process has the advantage of having a huge variety of supports ready for experimentation. Other readers will like to move back and forth between the two studios, making paper and using it as soon as it is dry. Some of the processes in the chapter "Before the Wax" actually require that the paper be fresh and wet, so it is possible to make paper and then begin to work with it immediately.

Some of you may know something about encaustic, but very little about the paper process or vice versa. You might want to select those techniques that are new to you or focus on only one part of the book. However you choose to use this book, I know that you will enjoy the experience of working with these two organic and renewable resources. I am excited to share my enthusiasm and my years of explorations with you, and I look forward to seeing where your own experiments take you.

IN THE PAPER STUDIO

ADVANTAGES OF A PAPER CANVAS

Paper is a perfect complement to wax. Wrapped around a rigid support, such as gator board, foam core or foam panel, paper can successfully handle two challenges of encaustic paint: weight and temperature.

Many artists use wood or cradled panel for their encaustic supports, but paper has several advantages over more traditional substrates. With wood, the larger the work, the heavier it becomes. The heavy weight precludes many artists from working on a sizeable scale. With a paper canvas, there is very little weight. In fact, a 36" × 36" (91cm × 91cm) canvas can be lifted and carried with one hand. Even though my work appears to be solid and heavy, many people are surprised by how lightweight it actually is.

Temperature is a worry to many encaustic artists who go to great lengths to ship their work only during moderate times of the year to avoid melting, chipping and cracking. A paper canvas is not as susceptible to temperature fluctuations because neither the paper nor its rigid interior support conducts heat or cold. The paper as described in this book is created thick and without sizing, making it highly porous and wax thirsty. I have shipped my work by ground without worry and without incident both in the dead of winter and the heat of summer. If boxed properly, these canvases are shipping friendly, impervious to the ordinary nicks and chips of handling and resistant to the extremes of climate conditions.

I've always been attracted to work that was non-traditional in shape, size or dimension. With these supports, I especially like the fact that I have the ability to begin my idea with the canvas itself. My canvas can be a circle or shape as easily as it can become a more traditional square or rectangle. I can incorporate the deckle of the paper or wrap the paper to create a classic canvas. I can add dimensionality or texture, create windows or levels and add to the natural texture of the paper with imbedded patterns.

Paper is versatile. While the paper is still being formed, I can color the pulp, add fibers and botanicals, emboss or create pattern. When the sheet of paper is wet and wrapped on the support, I can spritz it with watercolor, draw on it with inks or add objects to rust. When the paper support is dry, I can distress it with a torch and add texture with screened-on grout. And that is all before I even apply the wax! You might even find that you like your canvas without any encaustic paint or other media.

 scan for additional content

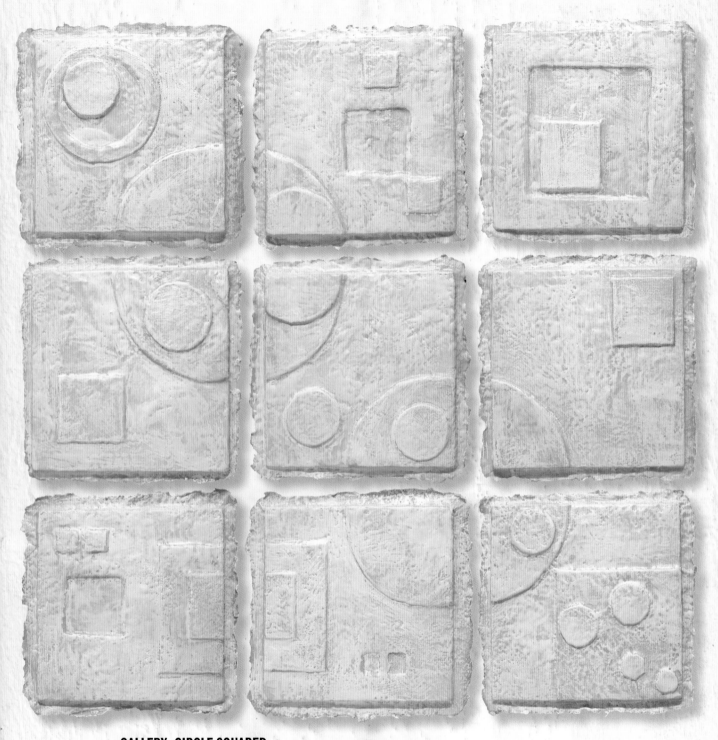

GALLERY: CIRCLE SQUARED

In this work, I explored the relationship between the circle (dynamic) and the square (static). I chose to create this larger work with nine white cast paper panels because the paper's curvilinear deckle created a kind of dynamic energy between the square panels. I like the way the viewer first is drawn into the work's dimensionality and texture and then finds a surprise as the image comes into focus when he moves farther away.
(cotton, abaca, beeswax, resin, white pigment)

TOOLS AND MATERIALS

Many of the supplies and tools you will need for both paper-making and encaustic painting, including such household items as a kitchen blender and an iron, can be found where you regularly shop, like at hardware and discount stores. If you frequent garage sales, estate sales or thrift stores, you can gather most of your basic equipment in one morning of treasure hunting.

Be sure to check your own kitchen cabinets and your garage, attic, and studio before you shop. On more than one occasion I have bought a piece of equipment only to discover that I already had one boxed up waiting for my next garage sale. Friends or neighbors also may be happy to give away blenders or heat guns that they no longer use. If you have the chance to recycle or repurpose items rather than purchase new, that is always preferable.

(You'll find more information on the tools and materials needed to set up your paper studio on page 20 and your encaustic studio on page 52.)

Once you have your studio set up, be on the lookout for unique embossing tools, interesting papers or fibers to incorporate, and mixed media products that can be used in either paper or wax. It is fun to share your finds with other papermakers or encaustic painters whose own discoveries will point you in new directions.

GLUES

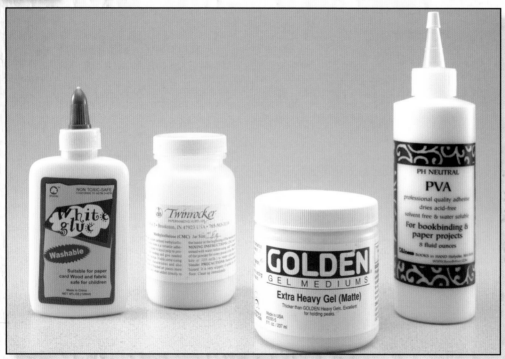

Glues that are effective on paper include white glue, methylcellulose, acrylic medium and PVA.

GLUES FOR USE WITH PAPER AND WAX:

METHYLCELLULOSE is a powdered adhesive derived from plant cellulose that is dissolved in cold water. It works especially well when adhering wet paper to itself. It is archival, reversible when wet and used extensively in book-making. Methylcellulose is usually purchased in powdered form from large art supply or papermaking stores. Because it is difficult to dissolve it in water, I find that I get a better consistency if I blend it for twenty seconds. The mixture can be stored unrefridgerated in a plastic, airtight container for several weeks and can be stored dry indefinitely. As a paste, it will continue to thicken over time and must be occasion-ally thinned with water. Methylcellulose is applied with any clean natural-hair brush.

PVA (POLYVINYL ACETATE) is a creamy white or yellow glue sold under a variety of commercial names such as school glue and wood glue. It is flexible and has strong quality of adhesion. It is naturally acid free. Apply it with a brush or flat tool, like a key card or flat blade. The glues made for wood are more acidic and less flexible, and they are not the best choices for working with paper.

ACRYLIC MEDIUMS are naturally adhesive and come in a variety of thicknesses. Regular matte medium is liquid and can be used with papers of up to 100 gsm. For heavier papers and foam core dimensional pieces, heavy gel medium is the best choice. Gel medium pieces need to dry overnight and should be weighed down under something like a stack of books.

WAX is a natural adhesive. If the paper is tissue thin, you can apply a layer of molten wax, press the paper to the wax and then affix it with additional layers of wax.

SUPPORTS

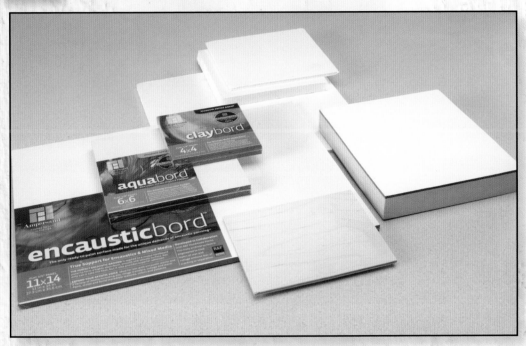

There are a number of supports available for encaustic painting. Artists use Aquabord, claybord, Masonite, birch or other wood panels. Encausticbord is the only material especially created for encaustic application.

When choosing a support for encaustic paint, look for material that is rigid and porous. You might choose one support over another based on suitability, weight or convenience. Most encaustic painters use wood or cradled panels as their support of choice. In this book, the word *support* refers to a rigid framework over which paper is wrapped or a rigid framework that is embedded into pulp. I have successfully used wood, foam core, gator board, Masonite, Plexiglas and cardboard as rigid supports. For the projects in this book, I suggest using foam core as the support of choice because it is lightweight, easily available, easy to cut with a box cutter and comes in a traditional white color.

The need for archival processes and materials is always a concern, but I have found that if I use acid-free paper pulp in my work, the chemical durability of the underlying support is not affected. I have sample work created with a non-archival foam core support that goes back twenty years. The paper shows no visible sign of deterioration or discoloration. Encaustic medium is a natural preservative, further reducing the risk of the work breaking down over time. That said, I now use only archival materials in my supports, relying on the old adage, "Use the best materials you can afford at the time." If you are concerned about the long-term stability of your work, you can paint a barrier with matte medium over your rigid support or encase your foam core or gator board form with an 1/8" (3mm) layer of acid-free foam core to seal out the non-archival inner core.

PAPER

Handmade paper comes in near limitless variety. This selection of papers includes mulberry, batik, botanical and screen printed paper, and stitched abaca.

This book focuses on using handmade paper with encaustic painting, but there may be a time when a patterned paper in the scrapbook aisle catches your eye or you fall in love with a sheet of exotic paper. You may want to use a printout of one of your own photographs or would like to distress or discharge a piece of commercial paper. You can use any paper with wax by attaching it to a rigid support. The thickness of the paper determines the type of glue and process used.

Besides weight, you also need to be concerned with the paper's absorbency because you will be using the paper for future wax applications. The wicking effect of paper comes from the fibers from which it is made, the length of time the pulp is beaten and the amount of sizing added in the paper-making process. Glossy paper intended for capturing great ink-jet photographs is less suitable for creating a support than are more porous print-making papers. You can test for absorbency by applying a drop of water to the paper that you want to use. If it sits on the paper without easily penetrating the surface, the paper is probably not your best choice for a support. If the drop immediately absorbs into the paper and spreads out, then that paper will create a good bond with the encaustic paint.

Paper thickness is described in industry terms as grams per square meter, or gsm. The following chart is helpful in determining the correct glue and process for attaching paper. This is not an exhaustive list of papers, and some papers, like silk papers, for example, come in different weights. Usually if the paper has been printed with a block printing process rather than an embossing process it will be more lightweight. Sometimes the paper will have identifying clues in its title, such as "tissue" or "cardstock." If you purchase your paper in a store, use the paper consistency description to determine your glue and process. If you order online, you can request the gsm of any paper to assess its weight before purchasing.

Some of the more interesting contemporary work on paper is being done by artists using found papers such as coffee filters, tea bags, pages of old books, dress patterns and strips of corrugated cardboard. If you look, you will find paper hidden in your everyday life, all of which can be glued or waxed to more rigid supports or shaped and incorporated into encaustic work.

MATCHING PAPER TO GLUE

GSM	Paper Consistency	Types of Paper	Glue	Process
10–70 gsm	tissue consistency to light text weight	tissue, Japanese, Bengali woven, silk, banana, kozo silk tissue, lace, mulberry tissue, rice	methylcellulose, wax	direct collage
70–120 gsm	medium text weight to light cardstock	Lokta, Indian silks, kozo, hand-painted batik, embossed, block printed, marbled, mulberry, scrapbook, ink jet, pastel, drawing, Mi-teintes	PVA, white glue, matte medium	wrap
120–150 gsm	regular cardstock	Tibetan batik, Indian batik, natural bark, reversible	PVA, gel medium	glue
150+ gsm	heavy cardstock	embroidered, BFK, watercolor mulberry, papyrus, saa	heavy gel medium	glue

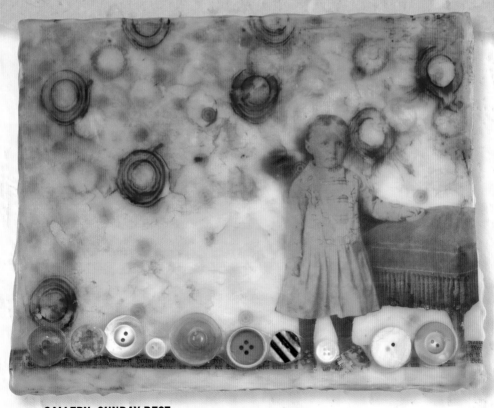

GALLERY: SUNDAY BEST
(wrapped paper support, wood burn, oil stick glazes, collage, antique buttons)

WRAPPING PAPER

Every artist I know has a lovely stash of handmade papers they have purchased over the years. These papers make beautiful beginnings for your encaustic paintings. Most commercially sold handmade papers sold commercially are created in other countries where papermaking is largely a labor-intensive, process. In purchasing these papers, I feel connected to papermakers all over the world. This adventure will begin with medium-weight paper wrapped around a rigid support. Handmade papers or your own images on ink-jet copy paper work especially well for this process.

Paper can be wrapped dry or wet. The process is the same, but the glue is different. In this demonstration, I wrap dry paper using gel medium. Wrapped paper creates better contact with the rigid support and provides cleaner edges. For this reason, I prefer to wrap paper whenever I can. Several good techniques can be used to wrap the paper and get a clean corner. The method I use is called a universal corner. It is a process that is fairly simple and reliable and works well on either wet or dry paper.

MATERIALS

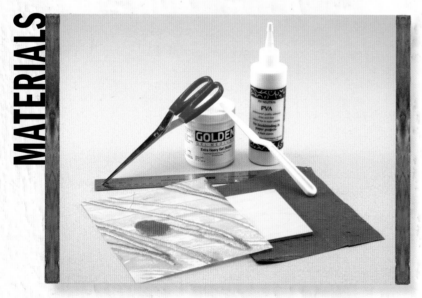

scissors

ruler

light cardstock or text-weight paper

gel medium or PVA (for dry paper)

methylcellulose (for wet paper)

glue applicator

craft knife

support

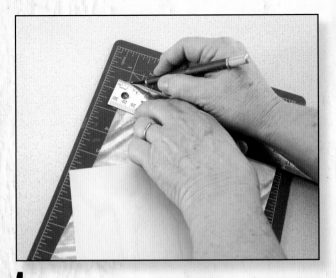

1 Cut a sheet of paper that is larger than your support on all sides by 2" (5cm) for supports with depths of ½" (12mm) or less, or cut it to 4" (10m) for supports with depths of 1" (25m) or more. For instance, if you have a 10" × 10" (25cm × 25cm) panel that is 1" (25cm) deep, you will need to allow for a depth of 1" (25cm) when you wrap to have at least 2" (5cm) to glue to the back of the support, making the paper size 13" × 13" (33cm × 33cm).

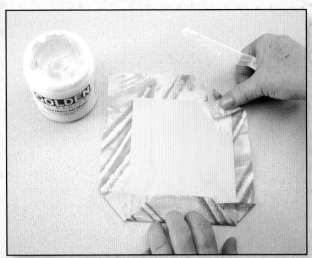

2 Place the support upside down on the paper so that you are working on the back of the support. Fold in each corner toward the center of the support, forming a square on the corner. Make sure the paper is tight against the edge of the support but not so tight that it tears. Allow for the depth of the support. Glue each corner down with gel medium or PVA glue.

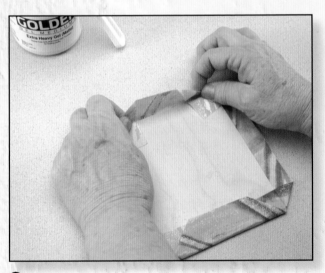

3 Fold in one of the sides. Be careful to pull the paper tightly, forming a sharp, clean edge, without causing a tear. Glue the side with gel medium or PVA. Repeat this process for all four sides, working opposite sides first.

TIPS

Follow the same basic process for wrapping sheets of wet paper with these changes:

- Paper will shrink some as it dries. Allow for the shrinkage by not wrapping the paper too tightly. It takes some practice to judge the amount of slack to allow, so you might want to practice on some test supports.

- Handmade papers, especially when wet, tend to be thicker and more bulky at the corners. Remove some of the bulk by gently cutting or tearing away the excess paper at the corners. Make sure the edges are the same thickness all the way around.

- Methylcellulose is the best glue for wet paper. Be generous with the application on both sides of the paper that you want to adhere.

- If the paper you are wrapping has a pattern, make sure you center the support on the paper and confirm positioning of the pattern before sealing the sides to keep the lines in the pattern straight.

GLUING PAPER

Knowing how to glue a sheet of paper onto a support comes in handy when you want to work with a photograph as the foundation of your painting or if you want to create a porous surface on a nonporous support like Masonite. Before the creation of encaustic gesso a few years ago, gluing white paper onto a birch panel was the only option for those artists who wanted to work with a traditional white ground.

MATERIALS

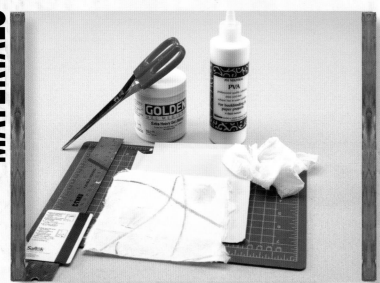

gel medium

PVA or white glue

rigid support (Masonite, Plexiglas, wood)

damp cloth

heavy cardstock or Rives BFK paper

craft knife

plastic palette knife or hotel key card

support

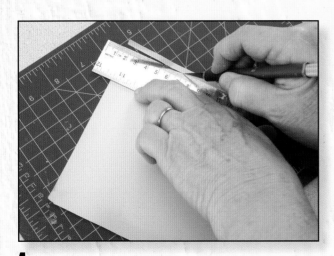

1 Cut your heavy cardstock paper about an inch larger than the surface of your panel.

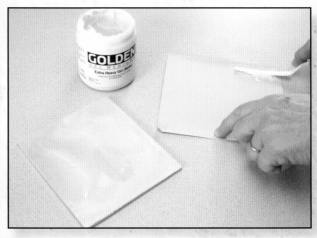

2 Apply a thin layer of gel medium to the paper and the support with an applicator such as a hotel key card or a plastic pallet knife.

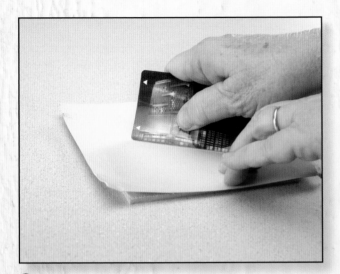

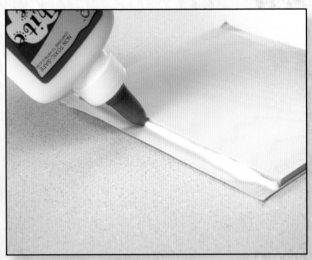

3 Allow the glue to air-dry until it is slightly tacky. Lay the paper on top of the support, making sure that it overlaps on all sides. Drag a plastic palette knife or hotel key card over the paper to remove any bubbles and create a good contact. Work from the center outward to the edges.

4 Using your finger or a small brush, clean off any gel medium that has seeped under the paper. If there has been little or no seepage, add a line of PVA or white glue to the underside of the paper as insurance against future lifting when the wax is applied. Weigh it down and allow it to dry overnight.

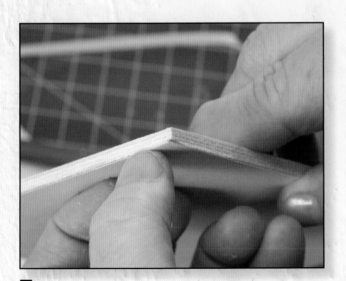

5 When the paper is dry, trim the edges with a craft knife. Check for lifting and add more glue if necessary.

TIPS

- The wax tends to want to pull away from the support, so it is necessary to make sure that the paper is attached very well from the beginning.

- If you are using a white glue or a matte medium that is fairly liquid, be careful with the amount of glue you apply. You do not want the glue to penetrate the paper because wax will not adhere to an acrylic glue.

INTRODUCTION TO HANDMADE PAPER

Paper has been made by hand for more than two thousand years. It was only with the steam-driven papermaking machines of the nineteenth century that paper has become commercialized and abundant. While today's technology may be moving us toward a day when paper will be out-moded, artists will always feel the lure of working with this versatile material.

Traditional papermakers begin the labor-intensive process of turning plant fibers into paper with a visit to their garden. Here they gather plants and other natural elements that will be soaked for twelve to twenty-four hours to begin the process of removing the lignin. Soda ash is added to the mix and the fibers are boiled for three or more hours. The pulpy fibers are rinsed well and then beaten. Some plants, like hosta and day lilies, can be beaten in a blender, but most others require a Hollander beater to complete the process.

Purists will hand beat the fibers into a pulp with two large paddles on a flat, hard surface.

If you are interested in using botanicals to make paper, several books that detail the process are available. For the purposes of this book, you will begin the process with commercially made papers and help out the earth by recycling. Essentially, you will reconstitute paper back into pulp in order to access its great flexibility. The wet pulp can then be cast, formed, blown, embossed, wrapped, colored and collaged into dimensional supports for encaustic painting or into sheets for monotypes and sculptural forms.

Three main components are needed for papermaking: pulp, a mould and deckle and a press. Within each component there are a variety of choices you can make in choosing equipment and processes, so a more detailed explanation of each is necessary.

PULP

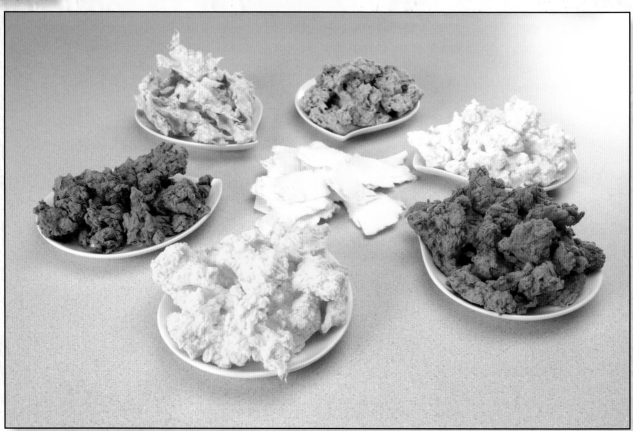

In the center is commercial paper torn and ready to be reconstituted into pulp. Unused pulp can be lightly squeezed and left to dry—it will store indefinitely.

Pulp can be made from any natural organic fibers. Each fiber has its own unique color and qualities.

Some fibers, like sisal and sabai, produce a paper closer to khaki in color. Abaca, a versatile fiber taken from the stalk of a special type of banana tree, produces a warm ivory color. When beaten longer, sisal, sabai and abaca become more translucent and stronger. All three have a quality of high shrinkage, which can be fun to work with in a sculptural format.

Cotton is the most common fiber for papermaking. The cotton ball is removed from the cotton plant and used in textiles for the making of cloth. The linter refers to the fibers that remain after the ginning of the cotton seeds. Cotton linter is inexpensive and can be purchased from a craft or papermaking supplier. If you want pure white paper that can be easily embossed, it would be worth the expense and trouble of ordering cotton. You can add cotton linter to some of your recycled materials or use it alone. Pulp is usually purchased in the form of dry compressed sheets, making it easily to reconstitute. In my work, I add abaca, a longer fiber, to the cotton to provide a stronger paper in a ratio of 2:1 (two parts cotton and one part abaca). I make unsized pulp because I want a really porous paper. Sizing is an additive that decreases absorbency and feathering when using inks or watercolors. It can be introduced to the pulp when it is beaten, or it can be painted onto paper after the paper is formed.

For those who want to get right to the supports, you can order pulp that has been pre-beaten to your specifications and delivered wet directly to your doorstep. Check *Resources* (page 124) for suppliers. In order to save shipping costs, check your area for art schools that have a papermaking department or your local artist directory for papermakers. They are often only too glad to provide pulp for a fraction of the cost.

You can also recycle commercial papers into pulp. Almost any paper *can* be beaten into pulp in a blender, but not every type of paper *should* be used. (See sidebar, *Papers to Avoid*.) There is a saying in the paper world, "quality in and quality out." If you are recycling low quality papers, such as newspapers or telephone books, your paper pulp—and whatever you create with it—will reflect that low quality. The paper will be acidic and will not hold up over time. If, however, you recycle high quality linen papers, the pulp will be better, stronger and will last longer.

PAPERS TO AVOID

- If a paper product is marked "recycled" it probably is not good for making pulp.

- Brown paper bags, newspapers and telephone books have a high acid content.

- Glossy magazines and color brochures are printed on clay-based paper that becomes gummy when pulped. The colors also turn gray when beaten. However, you can use bits of these glossy papers as inclusions later in the forming process.

- Heavy papers, such as 130 gsm and above, aren't good candidates for pulp because they take so long to soak through. Lighter weight papers make a better choice.

- Paper with a lot of toner, gummed edges, glassine windows from envelopes, staples and other detritus should not be recycled into pulp. The ink in heavily printed ink-jet paper is often water soluble. When wet, the ink bleeds together to form mud. You might want to test that paper in water to see what color you are likely to get.

WESTERN MOULDS AND DECKLES

A mould and deckle is a primary piece of equipment in making handmade paper. The mould is the screen where the pulp is formed into a sheet; the deckle is the frame that sits on top to hold the pulp in place. The mold and deckle can be as simple and inexpensive as two plastic embroidery hoops fitted with window screen or it can be a beautiful and treasured piece of equipment that will last your lifetime.

There are two types of Western papermaking moulds and deckles: a dip mould and a pour mould. The dip mould is designed to be *dipped* into a larger vat of pulp and the sheets *couched* onto *felts* that are then stacked into a *post* and pressed. Because the pulp is in a large vat, the dip mould is useful for making many sheets of one kind of paper. The dip mould is easier to make because the frames are meant to be held together by hand. Dip moulds and deckles are more plentiful and can be purchased from art and craft suppliers and from papermaking specialty stores.

The frames of the pour mould fit snugly together. The *mould* portion of this unit is deeper because it is designed to have pulp poured into the mould rather than dipped. The pour mould has the advantage of making each sheet of paper unique with different colors or inclusions. A pour mould and deckle can be made, but it is a little more difficult. It is also harder to find pour moulds on the market. Those that are available are designed to be unique and for that reason are harder to describe. If you are more interested in the creative process of making paper rather than making a lot of paper, a pour mould and deckle might be a better investment.

In this book I use the pour mold method. You will find instructions for making both dip moulds and pour moulds in Appendix I.

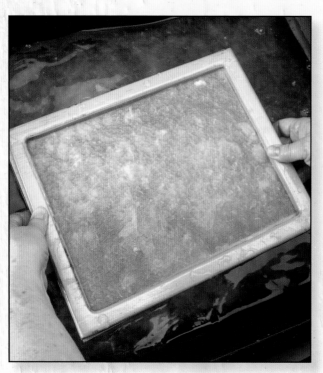

This mould is dipped into a vat of water and pulp. When the mould and deckle are lifted, a thin layer of pulp remains on the screen.

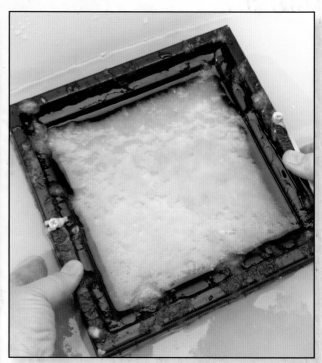

Pulp is poured from above into this pour mould. Again, the screening here catches pulp, which is then dried as paper.

PRESSING AND DRYING PAPER

The strength of the paper is directly related to the amount of weight or pressure you apply to the post of paper. In a commercial or university paper studio the press is usually hydraulic and is capable of pressing up to 5,000 lbs. or more, a difficult weight to replicate in a home studio. I have seen some really creative ways that artists press their paper. One artist I know drives her car back and forth over a sandwich of long, narrow boards, felts and paper. In my workshops I have been known to call for a group hug on top of our plywood press for additional weight.

Probably the easiest studio press to create is made from two sheets of plywood or laminated wood and four heavy-duty C-clamps. Make a sandwich of the wood, felts and paper, and then screw a C-clamp tightly to each side. Stand the press on its side for a couple of hours to allow for the excess water to drain. Instead of C-clamps you can use ratchet tie-downs wrapped around a 1" × 1" (25mm × 25mm) gutter added to the top and bottom of the press. You can keep the pressed paper on the felts and allow the sheets to air-dry somewhat. If you want a smooth side, you can turn the felt paper-side down onto a sheet of plastic and roll over it lightly with a rolling pin. Remove the paper from the felts when it is almost dry. The paper can be further pressed with a warm iron or flattened under heavy books.

If you are wrapping paper around a support, wrap the paper when it comes out of the press. The paper will air-dry on the support. As it dries, it will shrink slightly, creating a nice, snug fit.

SETTING UP THE PAPER STUDIO

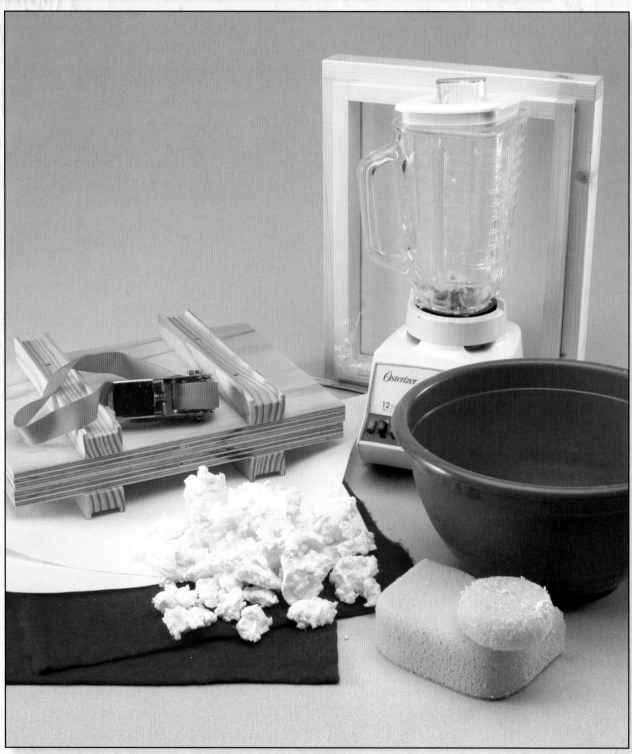

Aside from the press and mould and deckle in the background, you can see that most of the equipment in your papermaking studio can be purchased locally and inexpensively.

Papermaking is a satisfyingly hands-on process. But before we can get our hands into the pulp, you need to set up the paper studio and assemble the necessary equipment. Be warned: It will be messy. Working outdoors can be a pleasant and less messy alternative to an indoor studio. If you must work inside, cover a worktable with plastic sheeting in an area of the studio that can get wet. You will need the following equipment:

MOULD AND DECKLE: Frames for forming pulp into sheets of paper. You can purchase inexpensive moulds and deckles from craft suppliers or make your own with a little time and energy (see Appendix I). Keep in mind that the size of the mould and deckle will be the size of your sheet of paper. For the projects in this book, I suggest choosing materials no larger than an 8" × 10" (20cm × 25cm) sheet of paper.

DISHPAN OR LARGE TUB: A plastic dishpan or a plastic tub will serve as the vat for your paper. Make sure the container is large enough so that you can easily maneuver the mould and deckle in the vat. If you use a dip mould, you will want to have a larger tub to contain the pulp. If you use a pour mould and deckle, you can get by with a dishpan.

FELTS: Freshly made paper needs to be placed on fabric so that it can be pressed. Since the paper will adopt the texture of the fabric, it is best to use smooth weaves like interfacing (not the iron-on type) or old sheeting. You will get a better press if you also have lengths of white craft felt or lengths of old wool blankets sandwiched between your paper. The thicker felts will help absorb the water from the wet pulp. Cut several lengths of fabric and felts at least 2" (5cm) larger than your mould.

PRESS: Two rigid, nonabsorbent boards are used for pressing the paper. They should be at least 3"–4" (8cm–10cm) larger than your mould and deckle. Unfinished wood can be varnished to be water repellent and nonabsorbent. Four large C-clamps will hold your sandwich of boards and felts tight during the pressing process. You can also use baking sheets or heavy cutting boards piled with books or bricks as an alternative press.

KITCHEN BLENDER: Although you will be putting nontoxic materials in the blender, it is best to use a blender that is dedicated to papermaking. The blender must have a working pulse button.

PAPERS FOR PULPING: Business stationary, copier paper and computer paper all work well for making pulp.

OTHER MATERIALS: Sponges, plastic bucket, small plastic containers, plastic sheeting, plastic sieve.

GALLERY: FRETS AND FASTENERS
(cotton, abaca, beeswax, safety pins, thread)

21

MAKING PULP

The act of turning the waste from the cotton gin into paper begins with making pulp. I find the process of making pulp very meditative and magical. Although I know exactly what will happen when I bring a handful of paper scraps from the soaking bin to the blender or when I transfer prepared fibers to the beater, I am always surprised when I run my fingers through the pulp—it is clean, white and ripe for so many creative possibilities!

MATERIALS

papers for pulping

water

dedicated blender

plastic buckets (2)

plain white (unprinted) paper towels

TIPS

- Because it is made with natural fibers, wet pulp will eventually begin to rot and become smelly over time. If you want to store your leftover pulp for future sessions, drain the water using a sieve. Place the wet pulp in a zip-top plastic bag and store it in the refrigerator. Add a couple drops of household bleach to protect against mold. If you will not be working with the pulp for several weeks, lightly squeeze out the water and place the pulp on a screen to air-dry. Once dry, pulp can be stored indefinitely. Reconstitute the dry pulp by soaking it in water overnight and blending it again.

- Do NOT put pulp down a drain. When it dries it will clog the pipes. Remember to rinse off your mold and deckles, presses and felts when you finish working. It is much harder to clean off dry pulp than it is to wipe off wet pulp.

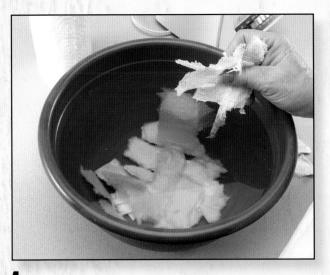

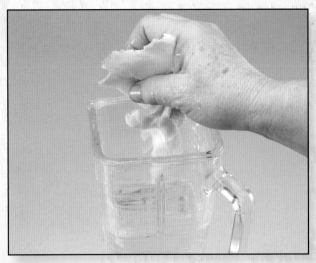

1 One day before making paper, tear your recycled paper into 1" (25mm) pieces. Add one torn sheet of unprinted paper towel to every five sheets of copy paper to increase the cotton content. You can judge the amount of recycled paper you need by the amount of paper you tear. If you tear ten sheets of copy paper and add some paper towel to the mix, you will get back approximately ten sheets in pulp. Add enough water to cover the torn paper, then let it stand for at least twelve hours.

2 Fill the blender no more than three-quarters full of warm water. Add a small fistful of soaked paper to the blender.

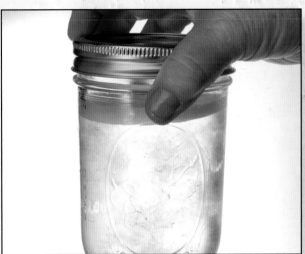

3 Press the pulse button several times to make a pulp. If the blender sounds strained, it is likely overloaded. Take out some pulp. For well-soaked paper a ten-to-fifteen second run should be enough.

4 To make sure the pulp is blended sufficiently, pour a small amount into a clear jar of water. If you see individual fibers floating freely, the pulp is ready. If you see chunks of paper, add more water and blend again.

5 Add the pulp to a clean plastic pail with enough water to cover. Continue to blend the rest of the soaked paper until it is all pulped. Now you are ready to turn this magical material into sculpture, sheets of paper or a canvas for your work!

FORMING A SHEET OF PAPER

To some it might seem a bit silly to go to all of the work of tearing up sheets of paper into strips, soaking the strips of paper overnight and blending the wet paper into pulp in order to re-form the pulp back into sheets of paper. There are many ways to work with pulp. Knowing how to make a well-formed sheet of paper is a basic skill upon which you will build throughout the book. Keep some pulp available because you will use the pulp in a variety of other ways as you spend more time in the paper studio.

MATERIALS

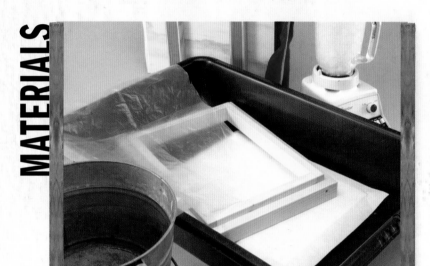

mould and deckle

pulp

plastic sheeting

vat of water

sponge

felts (interfacing, fabric or wool)

press

cord

TIP

Before you start, clear out a space in your paper studio to couch your paper. *Couching* is a term used to describe the process of removing the freshly made paper to the felt. Lay down one board of your press on a plastic-covered table. I like to cut a length of heavy-duty black trashcan liner as an additional protection between the wet felt and the board.

1 Dampen the interfacing with a sponge.

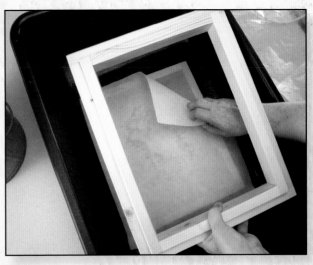

2 Place the wet sheet of interfacing on the mould. Connect the deckle.

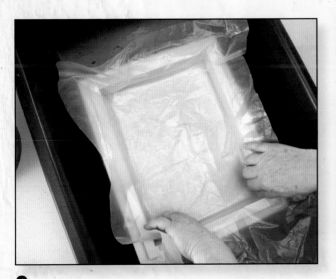

3 Create an artificial well with heavy plastic sheeting.

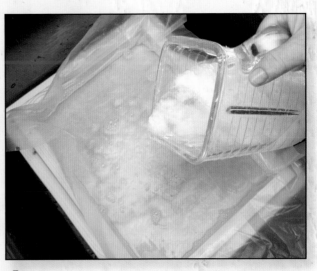

4 Add water to the well to about ¼" to the top. Add about a cup of pulp.

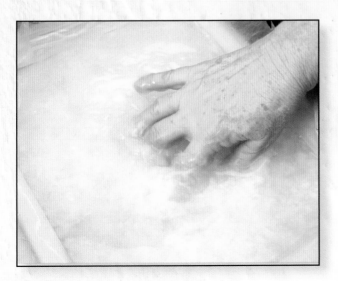

5 Agitate the pulp and water mix to disperse the pulp evenly throughout the well.

6 Pull out the plastic sheeting in one quick, continuous motion and allow the water to drain.

7 Lift and move the deckle to drain as much water as possible.

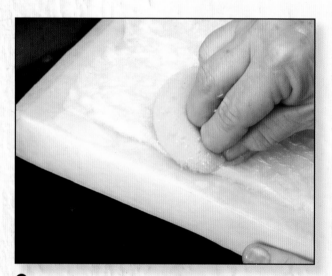

8 Use a sponge to absorb excess water.

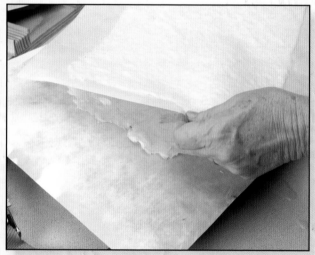

9 Begin your post by laying down your freshly made sheet of paper onto the press. Layer a felt on top of each new sheet of paper.

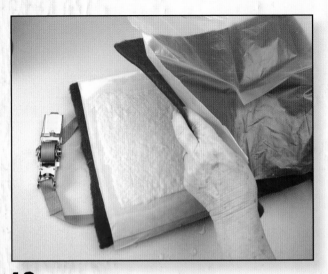

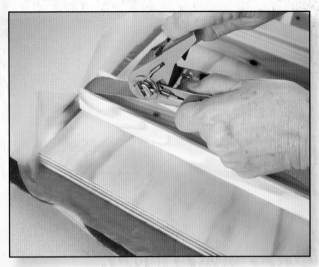

10 Continue to stack your paper and interfacing sheets between felts. The larger the post, the longer it will take for the paper to drain. Usually five or six sheets of paper are sufficient. Add a protective layer of plastic against the top and bottom of the press to protect the surface.

11 Close the press, tightening the C-clamps or ratchet tie-downs. Let the paper drain until there is no water seepage.

TIPS

- When using a dip mould, if the pulp falls off the mold before you can couch it, the paper is too wet. Allow more time for the newly formed sheet to drain. You should be able to hold the mold almost vertical without the paper sliding off.
- Another way to work with this process is to place the mould and deckle into the vat. Fill the vat until the water fills the mould and deckle but does not completely cover it. Add pulp to the water inside the mould and agitate. Lift the mould and deckle straight up to drain the water and then gently tip it side to side to drain as much water as possible. Then proceed with steps 8–12.
- Until you get the hang of the dipping and couching of the paper, you might not get the pulp evenly distributed on the mold. If the pulp is uneven, return it to the vat and start over.
- If the paper won't wrap easily around a support and it appears to be almost crumbling, you are probably using too much pulp. Although your handmade paper will not be as thin as commercial papers, it should appear even and consistent in texture. Return the pulp to the blender for reworking. Try adding more water and less pulp.
- When the paper comes out of the press it will be wet, but if the paper is so wet that it falls apart when you remove it from the interfacing, you didn't use enough pressure. Return your sheet to the press and add more weight.
- Wash your interfacing and air-dry your felts and press after each use to prevent mold and warping.

A NOTE ABOUT COUCHING

Until now you have been making your paper on a sheet of interfacing placed between the mould and deckle and then transferring both the paper and interfacing to the press. If you are using a dip mould and deckle, you don't use interfacing and will always need to couch your fresh sheet of paper directly to the interfacing. Anytime you create your sheet of paper on the screen of the mould, you will need to transfer the paper to a felt by couching. To couch a sheet of paper, drain it well so that the newly formed pulp clings to the screen when you lift it almost vertical. Place the mould onto a felt with screen side down. Use a sponge on the inside of the mould to remove some of the water that appears when you press down. Lift the mould. Your sheet of paper has been transferred to the felt.

MAKING PAPER WITH INCLUSIONS

You can create interesting and unique paper by incorporating decorative materials into your pulp. Threads and fibers, type, bits of colored paper or dryer lint are just a few of the things you can add to the vat or into the pour mould. Some paper suppliers sell packaged inclusions, but I think it is more fun to find your own. The inclusions are dispersed in the pulp. When a sheet of paper is pulled from the vat, the inclusions will be ingrained in the paper.

When it comes to inclusions, less is more and lighter is better. An overabundance of elements in the paper can be distracting. As a support for the wax, you are looking for an interesting background of shapes or colors that will function as an underpainting. Too many inclusions and you will lose the quality of the paper.

In my work, I find that inclusions with interesting textures or bold shapes are often more helpful in stimulating the creative process for my work in wax. If I try to create a finished work in the wet paper, then the paper becomes a finished work and doesn't need the wax. Sometimes that works, but more often I want the wax to have a place in the process.

MATERIALS

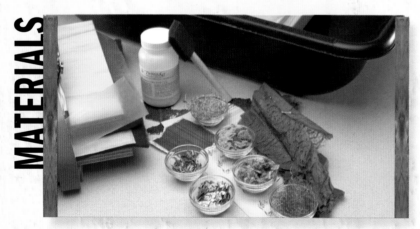

pulp

methylcellulose

brush applicator

press

inclusions (cut threads, shredded comics, dried flowers, collage paper, confetti)

vat

mould and deckle

TIPS

- For best results, use only two-dimensional, non-organic materials. There is always someone in my workshop that brings more exotic items to include. I've seen spices, dried peas, and dehydrated banana chips. They usually don't work. Organic materials will deteriorate. Three dimensional objects, like beads, prevent the paper from getting a good press.
- Be careful of materials that are not colorfast (the colors won't fade or run). You can ruin your felts very easily.

28

1 Add a handful of shredded paper or dryer lint to the pulp vat.

2 Agitate the pulp to disperse the inclusions. Make a sheet of paper, press and dry.

If you are using a dip mould, you will add your inclusions directly to the vat of pulp. In this way you can make a series of paper sheets that look similar. The advantage of using a pour mould with inclusions is that every sheet of paper can be different.

OTHER OPTIONS

Embedding dried flowers or paper collage elements into wet pulp is another way to work. For this process, do not add the inclusions to the vat. Instead, first make a sheet of paper. While it is still very wet, lay your elements on the wet pulp. Dip your hand back into the vat and bring up bits of wet fiber. Lay the fibers over the inclusions to incorporate them into the fabric of the paper. When pressed, the materials that you added to the paper will appear to be peeking out from the paper.

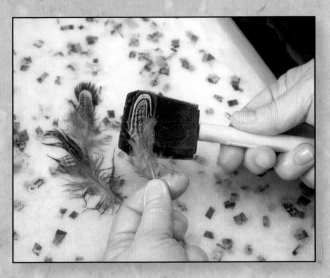

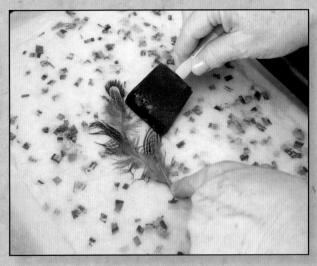

If you are working with larger collage elements or shapes on heavier paper, you can glue them in place with methylcellulose to ensure good adhesion.

EMBOSSING PAPER

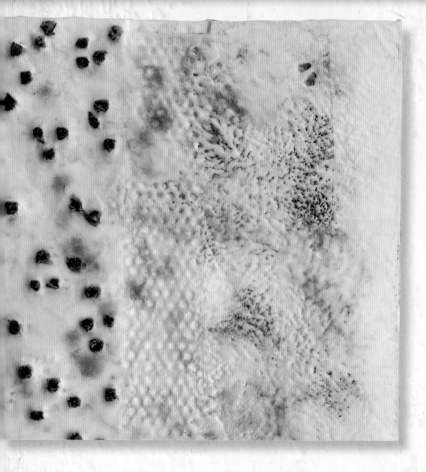

Handmade paper is naturally textural. You can achieve additional dimension by embossing the wet paper during the pressing process. The embossed areas can then be visually enhanced with oil sticks and wax glazes in the encaustic studio. You can emboss shapes, such as a square window or oval, by using shapes cut from craft foam or thin Plexiglas. Embossed paper is complex in both feel and appearance, but it's the easiest look to achieve in making paper.

STUDIO SAMPLE: BEACHES

This photo is a detail shot of a larger piece of art. In the photo you can clearly see multiple examples of embossing on the paper below the wax.
(*cotton, abaca, beeswax, resin, tar, oil paint*)

MATERIALS

embossing materials (metal/plastic screening, plastic place mats, lace, textured fabrics, wire, string, found materials that are flat)

newly formed sheet of paper

press

felts

30

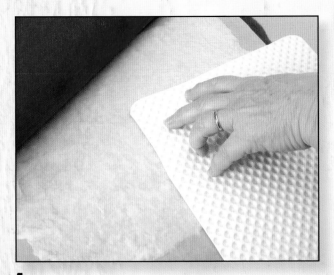

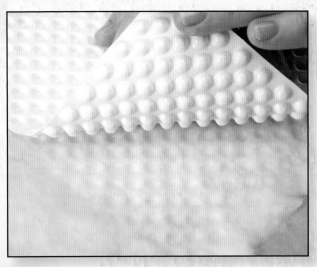

1 Make a wet sheet of paper and couch it onto a felt. Arrange your textural items on the paper. If you don't want the entire sheet to be embossed, place the embossing element partially on the paper and partially on the felt. Unless your felts are very thin, only the area exposed to the dimensional material will be embossed. If you are using interfacing or old sheets for your felts, this would be one time you would want to insert a cut-up section of a wool blanket or craft felt between layers.

2 After the paper is pressed sufficiently, gently lift the embossing material to check the quality of your embossing. You should see a pattern or shape made by the embossing element. If you want a sheet of dry paper for your work, do not remove your embossing element. Allow the two to dry together. If you want to work with wet paper (for example, to wrap around a support), be very careful working with the wet paper so as not to lose the dimensional quality.

TIPS

- Embossing is most effective if the cotton fiber content of the pulp is high. If you are using recycled copy paper, for example, and want to emboss your sheet, add some paper towel pieces to your pulp to increase the cotton content. You will get a thicker paper that will hold the embossing.
- Select embossing materials that are flat, dimensional and strong enough to withstand the force of the press. I once bought a low-relief plastic candy mold that I thought would give me a great honeycomb effect. I used a commercial press and added about 3,000 lbs. of pressure. The paper did have a lovely honeycomb embossing, but the candy mold collapsed under the weight and could not be used again.
- Test your materials for colorfastness before you try to emboss things like jute, colored laces and colored string. You might be surprised to find some unexpected color in your paper and even worse, on your felts.
- You can make your own embossing plate by applying hot glue or white glue in a raised pattern onto a sheet of thin Plexiglas.

COLORING PAPER

Coloring paper is very different from coloring on paper. The process of adding color to paper, sometimes called "painting with pulp" is organic. It involves actually changing the color of each fiber in the pulp and then reinserting the colored fibers back into the wet pulp using such "brushes" as a turkey baster or condiment bottle. Images are created by using stencils applied to the base sheet of paper or stencils on the mould and deckle. In the context of this book, you will only experiment with some simple techniques of coloring pulp because you will be apply color later on in the encaustic studio. If pulp painting interests you, several good books that offer more information into this fascinating process—an art form all its own—are available.

Coloring pulp can be easy and inexpensive. Both dyes and pigments can act as coloring agents, but they work in different ways. A dye is a color that becomes soluble in water, meaning the water takes on the color of the dye. Pulp is added to the dye water and over time begins to take on the color of the dye. In this process you can expect that the pulp would be a lighter hue than the original color and would be susceptible to issues of light and color fastness. Some dyes are also toxic. Carefully read manufacture cautions and always protect your hands with gloves when working with dyes. Dyes need the addition of soda ash and non-iodized salt to facilitate the chemical process.

Pigments, on the other hand, work with paper magnetically. Plant fiber (pulp) normally has a negative charge. Beating or blending increases the negativity of the charge. Pigments are nothing more than powdered minerals and do not have a charge. The positive charge is added to the water chemically through a substance called retention agent, purchased from a papermaking supplier. When pigment is added to a water bath with freshly beaten fibers and retention agent, the pigments will want to adhere to the paper … like a magnet to steel. As the pulp is stirred in the pigmented bath, all of the pigment will move into the paper fibers and the water will become clear again. Magic! When the pigment bonds to the paper fibers it is a permanent bond, so there is no fading or changing of color over time.

Most papermakers will use pigments rather than dyes to color their pulp. Dyes, though, are easy to use and accessible, so for the purposes of this book you will use the simplest form of creating colored pulp, which is blending colored tissue paper. It is the quickest way to get a variety of lovely colors to use for painting. You can also use dyes that come from organic materials such as tea, coffee and beets, to name just a few. I've included a chart of some of the more common household dyes and their formulas for exploration.

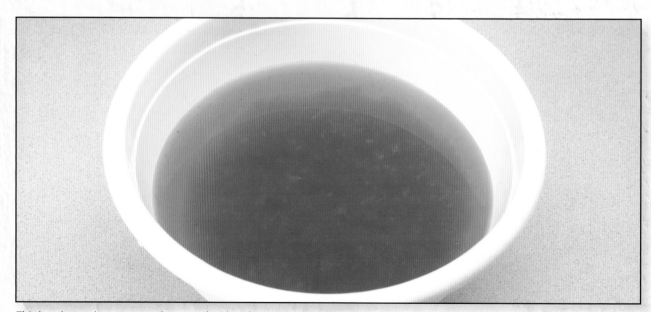

This bowl contains orange pulp created with a dye. Notice how the water itself is orange. If I had used pigment instead of a dye, you would see clear water with orange pulp in the bottom of the bowl.

DYE CHART

Color Process	Material	Process	Result
dye	turmeric	Mix ¼ cup (59 ml) powdered tumeric with 1 cup (236ml) water. Add to 1 gallon (3.8L) of pulp. Add ½ cup (118ml) white vinegar. Mix well. Allow to absorb color overnight.	golden yellow – not lightfast
dye	coffee/tea	Make a cup of strong coffee, instant coffee or tea. Dilute the hot liquid with 1 cup (236ml) cold water. Pour into a container with ½ gallon (1.9L) pulp and ½ cup (118ml) white vinegar. Allow the pulp to absorb the color overnight.	light brown – not lightfast less dilution will result in darker color
dye	vegetables (beets, onionskins, parsley)	Boil 1 lb. (453g) of vegetables in 3 quarts (2.84L) water with 4 oz. (113g) alum for an hour. Drain the plant fibers and allow to cool. Add 1 lb. (453g) pulp. Allow the pulp to absorb the color overnight.	pale to medium saturation of the original color – not lightfast
dye	food color	Add ¼ cup (59 ml) color to 2 quarts (1.9L) water with ½ cup (118ml) white vinegar. Add ½ gallon (1.9L) pulp. Allow the pulp to absorb the color overnight.	pastel version of the original color – not lightfast
dye	commercial dye	Prepare dye bath according to manufacturer specifications. Add pulp and allow the pulp to absorb the color overnight.	varies by manufacturer
pigment (purchased from a paper-making supplier)	water dispersed pigments + retention agent	Add a gallon of water to ½ gallon (1.9L) pulp in a bucket or plastic container. Add ¼ cup (59 ml) retention agent and stir. Add ½ teaspoon (2.5ml) pigment. Continue stirring until all or most of the color migrates.	brilliant and intense colors that are lightfast

MAKING COLORED PULP

Colored pulp can be used as a decorative element or it can be used to create imagery the same way as a painter might apply color. It can also be used to create a sheet of colored paper. Traditional papermakers often use colored pulp as their primary means of adding color and image to their work.

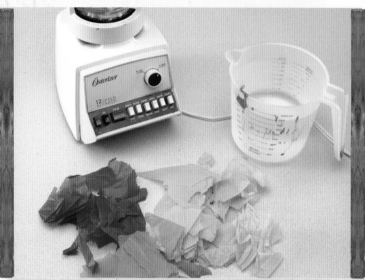

pulp

several sheets of colored tissue paper

water

dedicated wooden spoon

zip-top freezer bags (quart or gallon size)

dedicated blender

sieve

WHY TISSUE PAPER?

Tissue paper is readily found in craft stores. It comes in a variety of colors, ranges from pastel to vibrant and is often sold in inexpensive packages of assorted colors. Bleeding tissue paper is a good choice for this project because the dye in the paper is designed to be released with water. You can also use colored napkins or crepe paper, but I have found that tissue paper works the best.

 If you want to use the colored pulp in a decorative, painterly way, make sure the colored tissue paper is well blended into very short fibers. Add the contents of the blender to a squeeze bottle. If you want to make a colored sheet of paper, you will need additional pulp. Add the contents of the blender to a freezer bag. Close the bag tightly and refrigerate overnight.

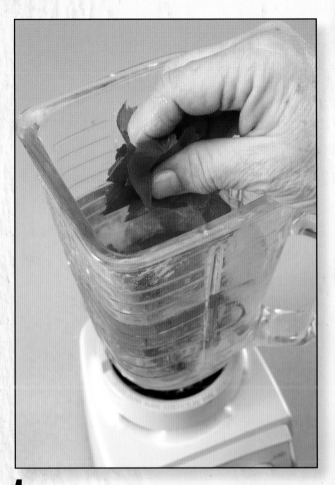

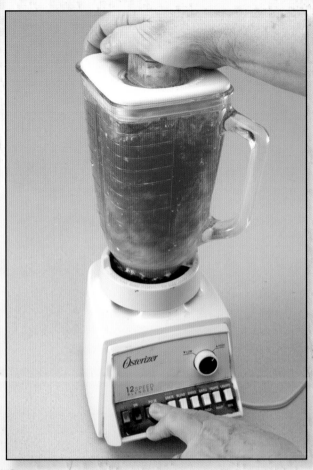

1 Tear one sheet of tissue paper into quarter-sized pieces. Fill the blender three-quarters full of water and add the shredded tissue.

2 Pulse on high for about twenty seconds. Remove the pulp by straining it through a sieve. Repeat this process for each additional color.

TIPS

- Try combining tissue paper colors in the blender to create your own color.
- Make a large batch of a color to create colored paper sheets. (Use a couple of layers of paper towels between your colored paper to protect your felts.)
- Coloring pulp is a messy process. Be sure to protect yourself with gloves and your space with plastic sheeting. Color has a way of appearing on exposed surfaces and leaving its mark.
- You can also combine pulp and pulped tissue paper. The resulting pulp will be pastel.
- Freshly beaten pulp takes color better, so if your pulp is older than a day, it is better to give it some fresh time in the blender.

PAINTING WITH COLORED PULP

Papermakers work with colored pulp in many ways to create imagery. Two methods are described here.

MATERIALS

press

sponge

plastic pulp tools (tweezers, medicine dropper, plastic spoon)

pulp

colored pulp

mould

sheet of window screen, approximately the same size as your mould

turkey baster or plastic condiment squeeze bottles

TIPS

- Instead of creating a colored background, you can create a design on only a portion of the screen. When it is ready for pressing, couch the design onto a fresh white sheet of paper. Press the two together. The two sheets of paper should bond, but if they don't, add a little methylcellulose to glue the two together.
- Protect areas of the white paper with masking by laying acetate shapes over your paper. Paint with colored pulp all over the freshly made paper using squeeze bottles or a turkey baster. Remove the mask. The masked areas will remain white. If you want, you can move the mask to different parts of the paper and paint with another color.
- Take a sheet of copy paper the same size or larger than the size of your paper. Cut out a design to create a stencil. Apply your pulp to the cut-out spaces in the stencil. Remove the stencil to reveal your design. Use additional colors as desired.

PROCESS 1

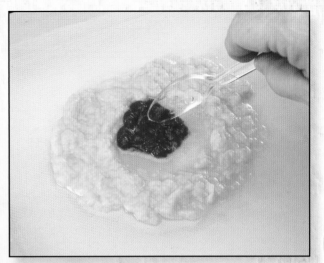

1 Set out bags of colored pulp that you have made. You might need to add some water to each bag to make sure that the pulp has enough dispersion. The colored pulp should be dense enough for you to lift by hand but not so dense that it looks or feels lumpy. If the pulp is too thick, add more water to the freezer bag. If it is too watery, you can pour out some of the pulp into a strainer and then return it to the bag.

2 Using tweezers, a plastic spoon or a medicine dropper, add colored pulps to create a design on your background paper. If you make a mistake, lift off the color from the incorrect area and reapply it elsewhere or cover over the mistake with more pulp. Chances are you won't be able to see the mistake when the paper is pressed.

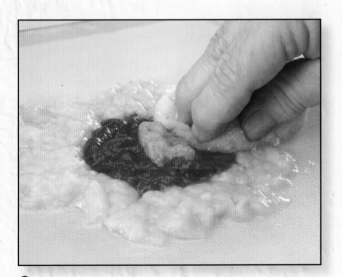

3 Add a layer of window screen over your design. Blot the pulp through the screen with a sponge. The sponge will draw up the excess water, then you can wring out the sponge. As more water comes out of the paper, gradually apply more pressure. When the paper is strong enough to move, couch it onto a felt and press normally.

Usually paper created this way is slightly thicker, so it is also possible to mount this sheet of paper for display. Keep in mind that pulp colors darken with the application of medium.

PROCESS 2

MATERIALS

- tissue paper
- blender
- jar or squeeze bottle
- felts
- press
- mylar or sheet of acrylic
- turkey baster or medicine dropper (optional)

1 Add tissue paper to your blender to make new colors. Instead of adding the pulp and water to a freezer bag along with white pulp, put this colored water/pulp into a jar or squeeze bottle. This pulp should be very thin and dispersed in a lot of water.

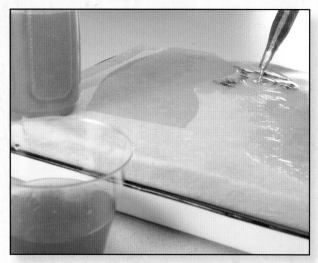

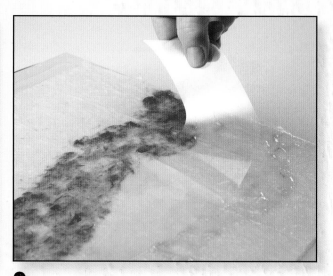

2 Make a sheet of paper and couch it on the felt, but do not press. You will work on this sheet of paper as if it were a canvas. Use sheets or mylar or acrylic as templates on the fresh paper. Use the squeeze bottle as your brush, applying the colored fibers onto the canvas. You can also use a turkey baster and a medicine dropper as brushes. Squeeze the rubber bulbs to draw up the pulp from the jar. Release the colored pulp onto your paper to create designs or areas of color.

3 Remove the mylar or acrylic strips and continue to add color as desired. When your painting is complete, press and dry the paper.

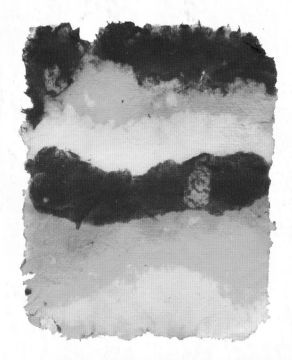

Paper created by painting onto a fresh sheet of paper is usually stronger than one created by the application in Process 1. This paper would be a good choice for wrapping around a support; the colors could then be used as an underpainting for the encaustic technique.

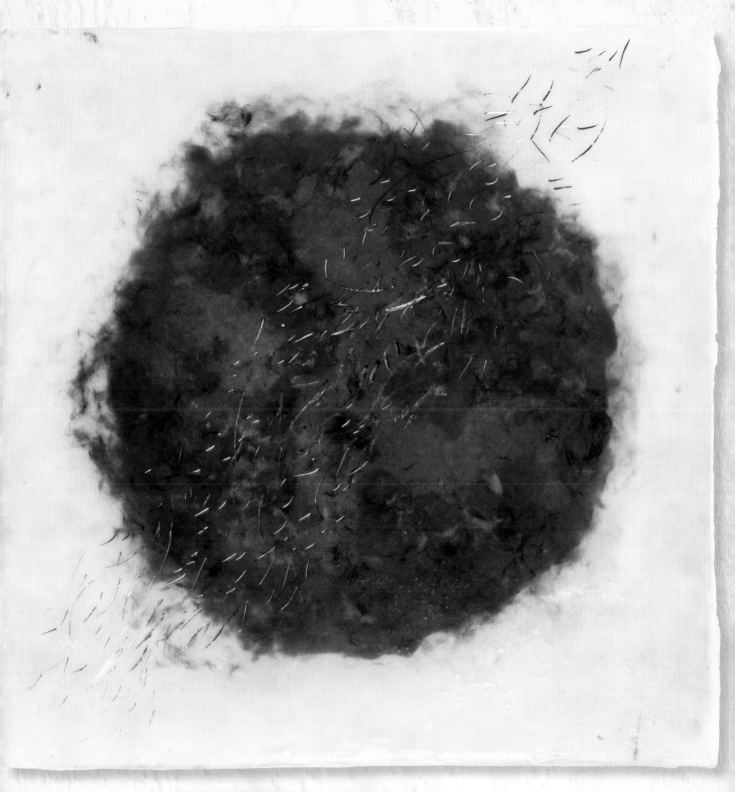

GALLERY: MIGRATION

The main circular image here was created using a mylar stencil. The paper was very wet, allowing some of the colored pulp to migrate under the stencil create a soft, feathered edge.

(cotton, abaca, beeswax, resin, bookbinder tape)

CREATING DIMENSIONAL SUPPORTS

For this book, the term *support* refers to the rigid foam core or gator board inner core paired with handmade paper to create a working canvas for wax. To my view, this type of support is the ultimate panel for encaustic painting. It will give you the most versatility in shape and allow you to move beyond the traditional square or rectangle. It provides a unique artist-created dimensional surface that sparks the creative fires and solves problems of weight, temperature and fragility often associated with encaustic work.

Many of my own works consist of traditional flat surfaces with handmade paper wrapped around archival foam core. These canvases lend themselves to a more traditional approach to painting and can actually be used with a variety of media, including acrylic paints, but I really enjoy working dimensionally. By planning in advance, I can create wells in which I can pour wax and embed three-dimensional objects. I can fashion imagery with shapes. I can add additional textural patterns by gluing on dots or squares of foam.

I find that making forms for paper is one part of the design process. When I make the paper, using options of inclusions, painting with pulp or embossing, I am adding another layer of interest to the work. Sometimes these canvases will sit for quite a while before I take them into the encaustic studio, where the real fun begins. That's when these canvases take on a life of their own. What I envisioned as doors or openings or portals become something altogether different with the wax.

MATERIALS

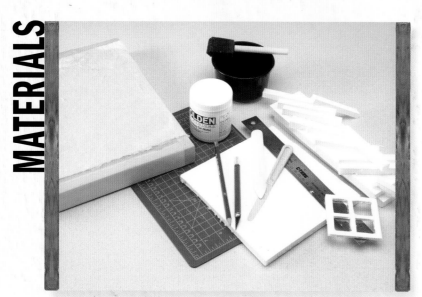

fresh sheet of paper

cutting mat

methylcellulose and applicator brush

metal ruler

³⁄₁₆"-thick (5mm) foam core scraps

craft knife

½"-thick (12mm) foam core support (1" [25mm] smaller than the size of your paper)

bone folder

gel medium and applicator (or any quick dry paper glue designed for foam core)

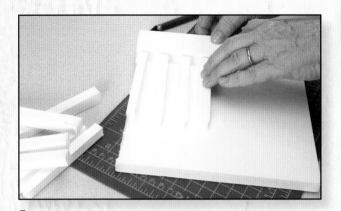

1 Cut shapes from ³⁄₁₆" (5mm) foam core and arrange them on your ½" (12mm) foam core support. You can either stop at the edges of the support or take the shapes beyond the edge of the support for an interesting look. Be sure to create different levels with your shapes so that there is both interest and variety in the design. If your design does go beyond the end of your support, you will have to add foam core to the underside of your shape to keep the back flush and well supported.

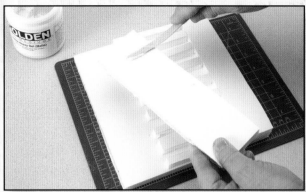

2 Glue your shapes to your support with gel medium or heavy-duty quick dry paper glue. Add weight to the glued support and allow it to dry overnight.

3 Make a sheet of wet paper at least 2" (5cm) larger than your support. Press it well. Remove it from the press, but leave it on the felt. Lay your support on the paper with the dimensional side down. Paint methylcellulose onto the area of the back of the support that will come in contact with the paper and add a coat of the glue on the paper as well. Do not glue the paper to the front of the support.

4 Wrap the paper loosely like you were wrapping a present. (See *Wrapping Paper*). Press the wet paper to the back of the support where you applied the glue.

TIPS

- It takes some practice to know exactly how loose or tight you will need to wrap the paper in order to allow for shrinkage. I find that it is better to wrap too loose rather than too tight. The paper will shrink quite a bit as it dries. When the paper is dry, it is a simple process to re-shape the edges by using your fingers or a tool. If it has been too tightly wrapped from the beginning, the dry paper will tear.
- The paper will pull toward the center as it dries and shrinks. Wax will also pull toward the center. Because of this natural tension, for any support 8" × 10" (20cm × 25cm) or larger, be sure to work with foam core that is at least ½" (12mm) in depth. Usually, you can use ³⁄₁₆" (5mm) foam core for smaller works without the fear of buckling, but I usually will glue two ³⁄₁₆" (5mm) forms together to create a stronger base.

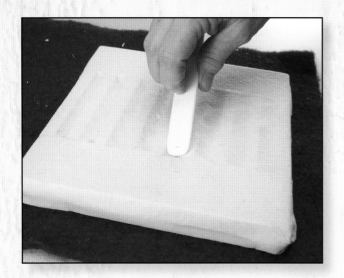

5 Turn over the support carefully and begin at the center of the support to mold the paper into the crevices and over the dimensional shapes. Use a bone folder or Popsicle stick to help with this process. Be careful not to tear the paper, but if you do, see the sidebar on *Repairing Paper Tears*. Allow the paper-wrapped support to dry for twenty-four to forty-eight hours. Larger, more dimensional supports might take as long as a week to fully dry.

REPAIRING PAPER TEARS

Don't be discouraged if you tear the paper in the wrapping or shaping process. Wet paper is very forgiving and can be easily repaired. Dry paper is harder to repair.

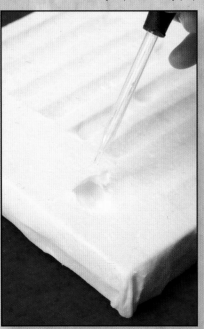

If you tear the paper while stretching it around a dimensional area:
Add enough water with a sponge or eyedropper to "fluff the pulp," that is to lightly separate the fibers from one another with water. Gently pat the torn area back together until you cannot see a visible line in the pulp. Press the pulp by hand with a dry sponge to remove any extra water from the area.

If you create a hole in the pulp or accidently remove too much pulp:
You can splice back pulp easily. Fluff the pulp in the area around the hole. Pull from your vat fresh pulp about the size of the needed repair. Make sure that the pulp has been loosely screened and kept juicy. Apply the pulp to the tear, then add a little more water to reopen the fibers and pat in place. Press the pulp by hand with a dry sponge to remove any extra water from the area.

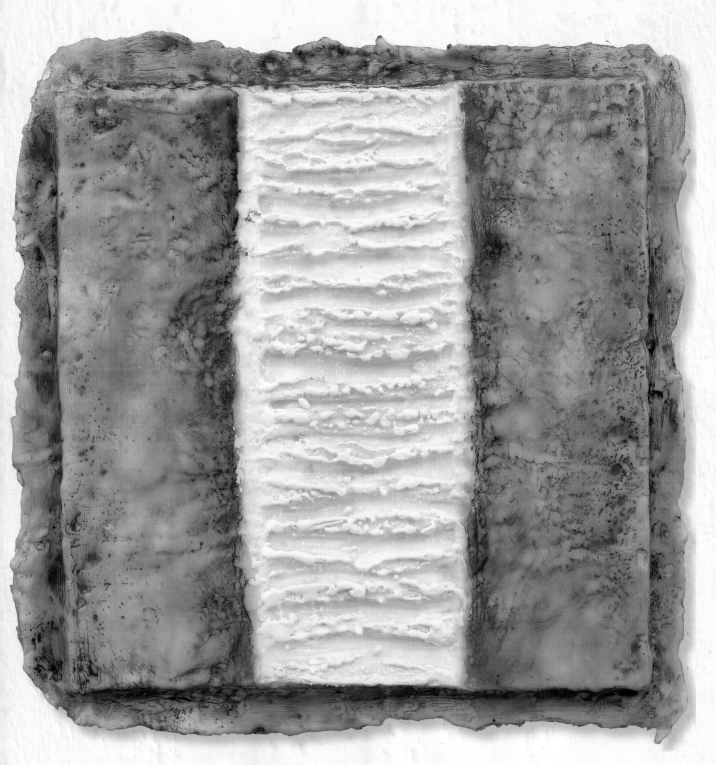

GALLERY: RAPIDS

In this work, I used the inner dimensionality of the support as a surface to dry brush cooling wax. The wax surface began to grow in interesting ways as I brushed the wax repeatedly down the center.
(cotton, abaca, pigmented beeswax, resin, oil)

EMBEDDING A SUPPORT

One of the more attractive qualities of handmade paper is the deckle, the uneven edge of the paper. The deckle edge is created by the paper pulp feathering between the mould and deckle in the forming and pressing process. If you want a support with such an edge, you will need to embed the support between two sheets of wet paper. The deckle will be stronger than what it appears because it will have the depth of two sheets of paper rather than one.

MATERIALS

½"-thick (12mm) foam core dimensional support (1" [25mm] smaller than the size of your paper)

pulp

press and felts

bone folder

sponge

1 Cut a support that is 1"–2" (25mm-50mm) smaller than your mould and deckle. Make a fresh sheet of paper, drain it and remove the interfacing and sheet of paper from the mould.

2 You will be working with wet pulp taken directly from the blender. Lift out handfuls of pulp, letting some of the water drain through your fingers. Place the pulp over the entire support, covering the edges.

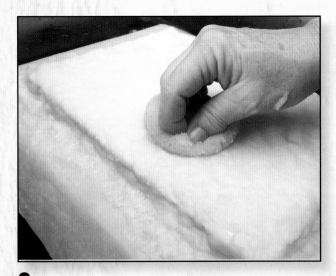

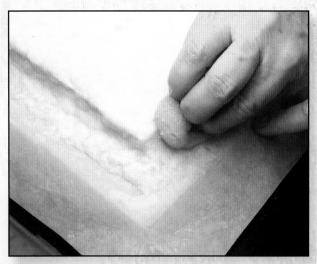

3 Using a large sponge and beginning from the center outward, gently remove the water from the support. The process of sponging extracts the water. When the sponge is soaked, squeeze the water out. Continue in this way until you begin to see the dimensions of your support. Foam core cannot hold up under the pressure of the press, so all supports created this way will need to be hand pressed.

4 Once you have removed most of the water, increase your hand pressure to extract even more water. The deckle is created by the two unsupported pieces of paper as they are pressed together with the sponge. If you are working with a dimensional support, use a bone folder or your fingers to delineate the dimensional aspects of your support. Allow the paper-wrapped support to air-dry for twenty-four to forty-eight hours. Larger, more dimensional supports might take as long as a week to fully dry.

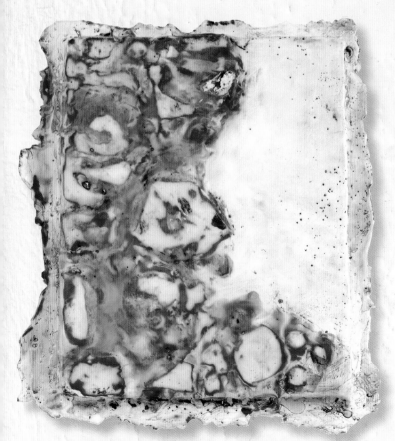

GALLERY: WHITE CHOCOLATE SUNDAE
The interest in this work is both the dimensionality of the support and its lovely deckle.
(dimensional paper support with decklewood, opaque paint layers, oil stick)

TIP

Hand pressing is a labor-intensive process and most of the time you will want to stop long before you are done. Pressing, though, is an important step in the papermaking process because a good press will add strength to the finished product. You will know that the press is done when you can press a finger into the wet pulp and you do not see a water residue.

CASTING PAPER

The dimensional forms that you created in earlier demonstrations are one-of-a-kind pieces. You might be able to make a similar form, but you will seldom be able to re-create the exact support because each stage of the process is made by hand. That adds to the value of your work. Even the canvas is a work of art.

There might be a time, however, when you will need multiple paper copies of a unique shape or design to use in your work. If the design is intricate, it will be very difficult and maybe even impossible to replicate the design. I once was asked to create a paper retablo for a photographer who was creating a body of work about an all-women mariachi group in South Texas. She had in mind a particular ornament for the top of the retablo that had to be cast to be duplicated. I used the process below to create that ornament and to duplicate it in paper.

PART ONE:
CREATING A SIMPLE ONE-PART PLASTER MOLD

MATERIALS

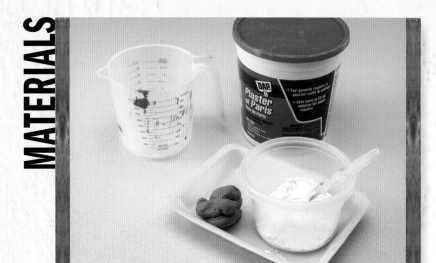

sculptor's clay or potter's clay

plaster of Paris

disposable plastic container

shallow deli or grocer's tray

measuring cup

sponge

TIPS

- If you would like to see this process demonstrated, you will find many online videos showing this exact process or a variation of this process.
- There are many ways to make molds and many materials from which to make them. Probably the simplest and easiest is the negative mold made from plaster of Paris.
- Because this is a time-sensitive process, it is best to gather all of your materials before you begin the process.

1 Use sculptor's or potter's clay to create the forms you want to replicate. Make sure the forms have no undercuts (shapes that fold back on themselves). Undercuts will make it difficult to lift the mold from the plaster and to remove the paper positive.

2 Mix the plaster according to the manufacturer's instructions.

3 Fill a deli or grocer's tray with the plaster mixture and embed your clay forms lightly into the surface of the wet plaster. Allow the plaster to dry completely, and then remove the clay forms.

4 Add a handful of wet pulp to the plaster mold. Completely cover and overfill the mold with the wet pulp. If your plaster mold is strong and thick, it is better to remove the tray from the mold. If your mold is delicate and might break under pressure, leave the mold in the tray.

5 Using a sponge, remove excess water from the pulp. Allow the pulp to dry completely.

6 Lift the paper cast from the plaster mold gently to prevent tearing. If a section of the paper does tear in the process, repair the area with PVA glue.

PART TWO:
CASTING PAPER WITH NEGATIVE MOLDS

Now that you have created your negative mold, it is time to make a positive paper cast. You will want to make up a lot of pulp because the cast will usually be thicker than the sheets of paper you made in early sections. Make sure your plaster mold is dry before you begin to work with pulp. Plaster is fairly fragile before it has time to cure completely. Plaster molds are good because the plaster actually draws out the water from the pulp, helping it dry. If you are working with a found mold, like a meat tray or a commercial mold like a candy mold, you will have to allow more time for the paper to dry.

MATERIALS

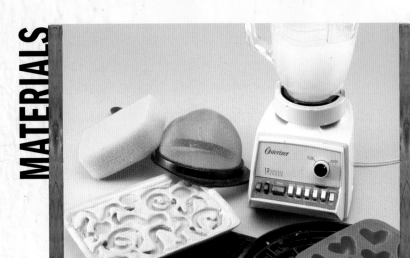

negative mold

pulp

strainer

sponge

1 Pull up some pulp from your pulp bath using a strainer or a piece of screen. For this process you will want to work with the paper very wet. Take the wet paper and add it to the negative space in the mold until the mold is overfull.

2 Use a dry sponge to begin lightly sponging the pulp to remove water. As the water is drawn into the sponge, the pulp will compress, When you have most of the visible water removed, increase the pressure so that you are both pressing the pulp and continuing to draw up water. You will know the cast has a good press when you can press a finger into the pulp and you do not see water puddle. Leave the cast to air-dry for several days. The cast is ready to be removed when the paper pulls away from the sides of the mold and the mold is no longer cool to the touch.

TIPS

- You can make a positive form in paper from a negative mold. The resulting paper cast can be used to create a sculpture or it can be glued to a paper support to create added dimension.

- You can also use found objects as negative molds. Packing materials, Styrofoam and plastic trays often have interesting patterns that work well for casting paper.

- Casting paper pulp directly over organic found objects, such as large rocks or landscape concrete, can yield interesting starts to sculptural forms.

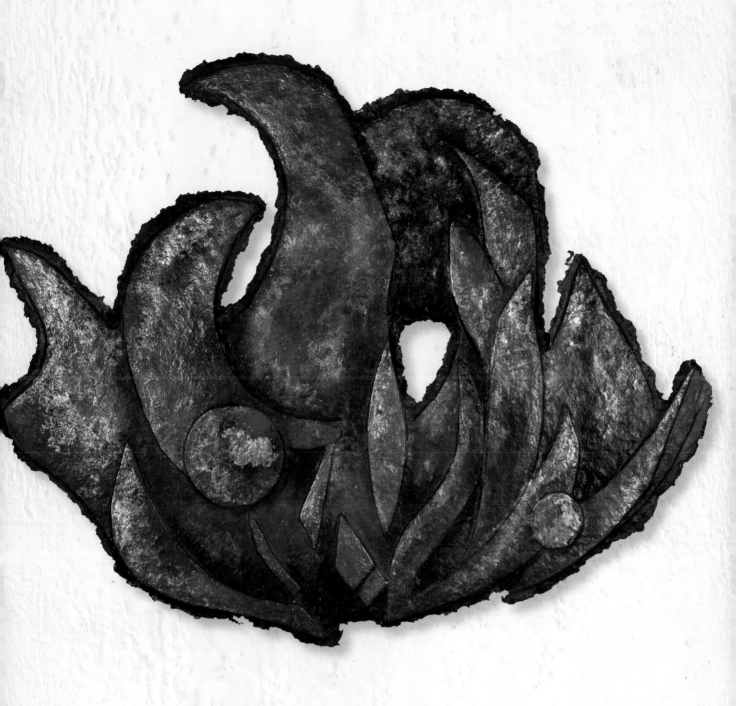

FIRE AND ICE
In this large piece, I used my own three-dimensional support as a mold. Instead of making a negative mold, I applied the wet pulp over support. *(cotton, abaca, pigmented beeswax, resin)*

IN THE ENCAUSTIC STUDIO

THE RESURGENCE OF ENCAUSTIC PAINTING

Encaustic painting has been around for as long as papermaking. While artisans in the East were making paper some two thousand years ago, Greco-Roman Egyptian painters were adding pigments to molten beeswax in their studios to capture the likenesses of the aristocracy in wax. These portraits were displayed in the home during the life of the subject and mounted to the mummy at the time of death. Unlike paper, encaustic painting became a lost art form shortly after the decline of the Roman Empire, as artists turned away from the difficult and temperamental materials of wax toward the more artist-friendly tempera and oil.

With the discovery in 1888 of the Fayum portraits—a cache of several hundred wax paintings near Fayum in Egypt—artists began to explore the process once again. Jasper Johns was inspired by these early works and began a lifelong love affair with wax. Today, he is considered the father of modern encaustic painting because his explorations with the technique and materials initiated a worldwide resurgence in this ancient art form.

Until the early part of the twentieth century, most of what was known about encaustic painting was shared by word of mouth in the artist community. Bad information and unsafe procedures led to premature deaths for many of the early experimenters of encaustic painting, who contracted illnesses from heating petroleum products or taking the wax to toxic temperatures. Without understanding the importance of fusing wax between layers and the need for a porous/rigid support, much of that early experimental work has not survived.

Today, however, numerous books, instructional videos and professional forums provide the information artists need to learn new techniques. A growing number of entrepreneurs are producing an ever-widening array of encaustic-related materials for this burgeoning market.

What makes encaustic so exciting for artists today is the versatility of the medium. Paintings are immediate, but can be reworked indefinitely. Wax can be applied to a multitude of supports, from cradled panels to bisque-fired clay. Color can be painted on in thin, luminous layers or heavily textured impasto strokes. The materials are noncaustic and natural, creating an effect that mimics more toxic paints. The finished work does not have to be varnished or protected by glass. The wax adapts itself to techniques that come from printmaking, photography, painting, sculpture and mixed media, offering artists a multiplicity of possibilities.

 ← scan for bonus content

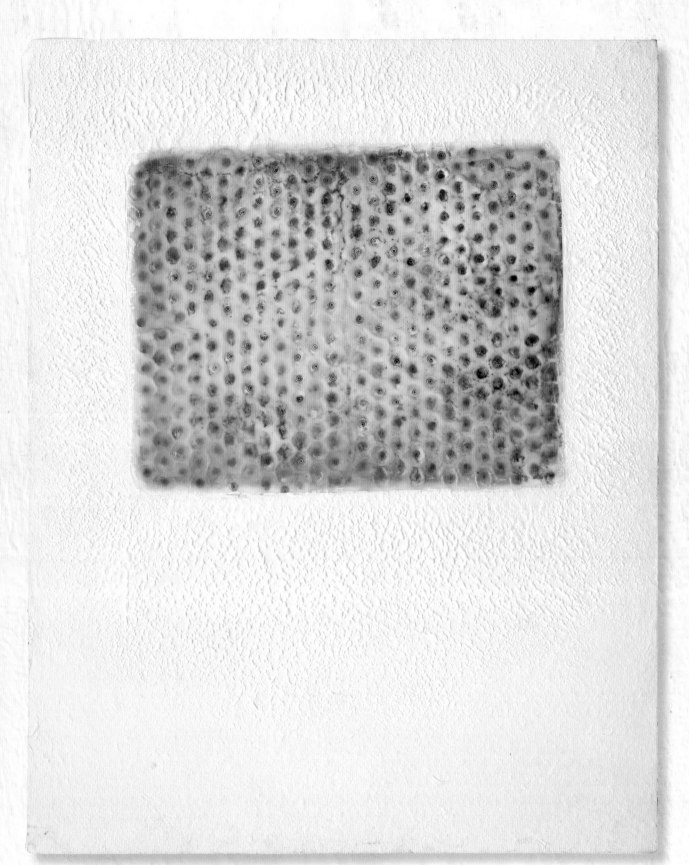

GALLERY: HIVE AND HONEY
The interest in this piece came from deeply embossing the paper in the press. The processes you will learn in this section of the book—wood burning, torching, applications of oil and wax—were applied only to the embossed area of the paper. A light dry brush of white pigmented wax onto the white paper created a nice contrast of textures.
(cotton, abaca, beeswax, resin, oil)

TOOLS AND MATERIALS
FOR WORKING WITH WAX

Like with papermaking, only a few basic pieces of equipment and a handful of materials are needed to get you started in this exciting medium. If you used this book from the beginning, you have an impressive stash of lovely, dimensional and embossed supports ready for wax. Now the real fun begins, so let's get started setting up the encaustic studio.

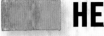 ## HEAT

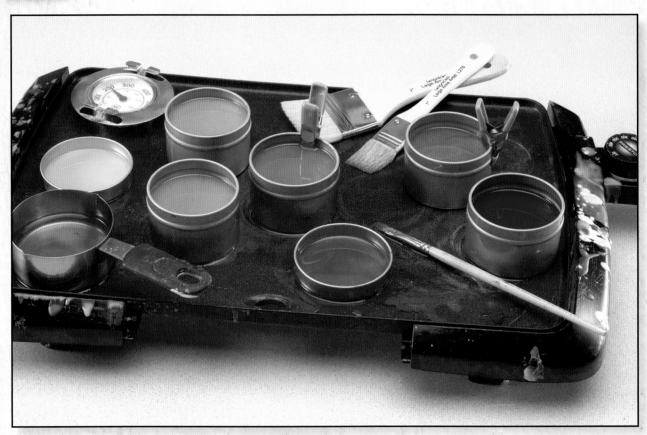

A pancake griddle, tuna cans, inexpensive brushes and a surface thermometer are all you need to get started.

Heat is the one ingredient that sets encaustic painting apart from all other mediums. The paint goes on in a molten state and the layers between wax applications must be fused together in oder to render a stable painting. Artists heat their wax in a variety of ways and keep it at a constant temperature. Many use an ordinary pancake griddle or electric frying pan purchased from a thrift store or discount store. Others use heat palettes created especially for encaustic painting (see *Resources* for suppliers). Some artists use tuna cans for melting their paint. Others, who like to mix colors directly on the palette, prefer a lighter and smoother surface. Suppliers who make hot palettes for encaustic work use an anodized aluminum surface to prevent pigment discoloration.

Fusing is another way that heat is involved in encaustic work. Each layer of wax must be bonded with the layer before to ensure that the wax will not peel away or lift off from the support. Artists use a variety of fusing tools in their studio because unlike the hot palette, each fusing tool works differently on the wax.

HEAT GUN: A heat gun uses a combination of heat and air. Originally designed as a paint remover, these guns can be purchased from hardware stores for about twenty-five dollars. It is probably the fusing tool of choice for most artists. I use a heat gun for most of my work on paper because it not only fuses the wax, but adds interesting patterns to the oil residue between layers.

EMBOSSING GUN: This is a mini-version of a heat gun. It is formulated for use with embossing powder, so while it will have both heat and air, the airflow is greatly reduced. This makes an embossing gun perfect for fusing transfers or small areas of a larger work. Be aware that some embossing guns have a small air vent above or to the side of the nozzle. Unless you are aware of this, you will be surprised to find the wax melting to the right or left of where you intended. Purchase embossing guns from a craft store.

TORCH: Torches come in several sizes. A crème brûlée torch is small and easy to use, especially if you work with small detailed pieces. Propane torches have removable tops that attach to inexpensive canisters. If you invest in a torch, select one that has an instant on/off trigger igniter and an adjustable flame. Torches work well for larger canvases and if you want to fuse without air. I use the torch to smoke and scorch the paper before I apply wax.

IRON: Some artists use a travel or craft iron exclusively as a fusing tool. They like the way the iron melts through several layers and reshapes the imagery. I don't use the iron much in my work because my paper pieces are often dimensional. The iron works best on smooth, flat surfaces.

OTHER FUSING TOOLS: Some artists use the sun as a fusing tool by setting work directly in the sun and allowing the wax to become glossy all over. Be ready to cover the work immediately at this stage. The images can quickly get beyond control. Others use a heat lamp for the same purpose. It fuses in the same way as the sun but allows more control of temperature and fusing area.

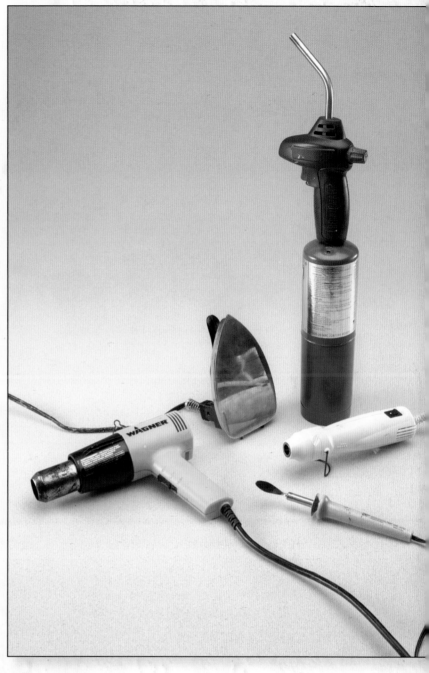

Artists use a variety of fusing tools—including embossing guns, heat guns, irons and torches—to serve their purposes.

WAX AND RESIN

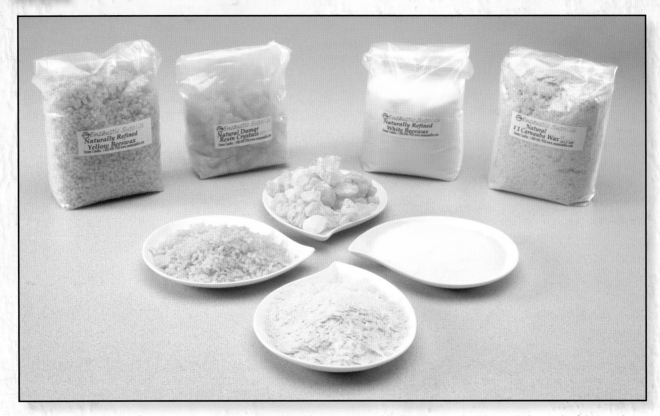

Encaustic medium is made from beeswax and damar resin, although some artists add other waxes to the mix to suit the needs of their work.

ENCAUSTIC MEDIUM is the base ingredient for encaustic paint. When used without pigment, medium provides a visual depth and a protective layer. Usually medium is comprised of beeswax and damar resin, although some artists add other waxes into their medium to suit the needs of their work. All of the encaustic paint suppliers offer medium for sale. When you are just beginning, it is better to buy medium than to try to make it. Later on, when you know the needs of your particular work, you might want to try your hand at making a batch of medium that suits your process. (See *Appendix* II.)

 BEESWAX is the main ingredient in encaustic painting. It has a warm color and releases a soft fragrance as it melts. It is natural, renewable, nontoxic and completely safe when used properly. Beeswax is sold as filtered, often described as "white," or unfiltered, labeled "yellow." Most commercially made medium and paint is made from filtered beeswax. The yellow pollen does add a yellow undertone to the color.

 DAMAR RESIN is a natural resin that comes from fir trees. Some painters use only beeswax in their process, but most add damar to the wax to increase the melting point and

to cure the painting. Damar will continue to cure long after the art is completed, pushing impurities toward the surface. The damar provides for a high gloss shine that can be buffed on the finished painting. Although a newly created piece can be shined with a soft cloth or nylon stocking, the shine will fade until the work is fully cured.

OTHER WAXES:

- **CARNAUBA WAX** is used only as an additive in medium. In its natural state, carnauba wax is brittle with a slight yellow cast. Extracted from the palm tree, carnauba wax is added in small amounts to make the medium harder and more resistant to surface scratches.
- **SOY WAX** has a very low melting point of 113–122°F (45–50°C) and therefore is not a good candidate for medium. Soy wax is often sold for cleaning wax brushes because it contains a natural oil conditioner.
- **PARAFFIN** is a petroleum product with a low melting temperature 120–140°F (48–60°C) and brittle characteristics that make it a poor choice for wax medium.

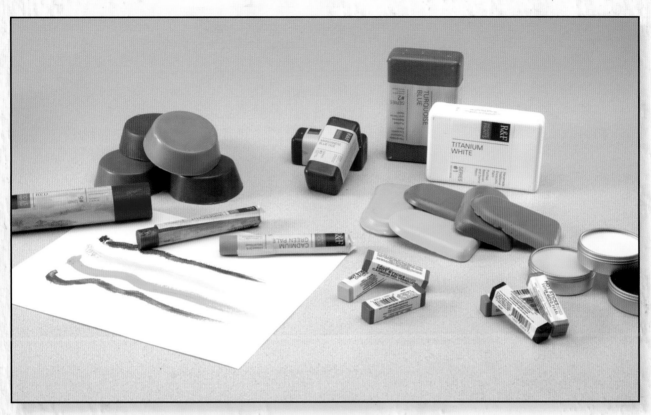

Encaustic paint is made from medium and pigments. Each paint supplier produces paint in different sizes, shapes and ratios of paint to medium.

In 1949, the book *Encaustic Materials and Methods*, by Frances Pratt and Becca Fizell, detailed the available information on making encaustic paint, but what was known then was incomplete and often dangerously incorrect. Around the same time, Joseph and Pauline Torch became interested in carrying a line of quality encaustic paints in their store, Torch Paint Supply, and they developed the first safe paint formula. In the 1980s, Richard Frumess worked with Torch, and then started R&F Handmade Paints. In addition to developing new products, R&F also offered workshops and instructions, broadening the appreciation of the medium among artists. Today, R&F has a full line of paints, oil sticks, medium and other encaustic materials, along with an extensive workshop schedule.

Enkaustikos was started in 1996 by brothers John and Mike Lesczinski and now uses a state-of-the-art milling process and a computerized milling machine. Enkaustikos offers innovative products such as Hot Cakes, ready-to-use paint in a tin, and Hot Sticks.

R&F and Enkaustikos are by far the largest manufacturers of encaustic paint, but there are some artists who offer their own lines of customized colors. Evans Encaustics specializes in highly pigmented paint designed to be extended with the addition of medium. Northwest Encaustics offers exceedingly smooth paint and packages paints in reusable tins. Miles Conrad Paints offers a palette of colors that reflects his Southwest environment.

Commercial paint is made from artist-grade pigments, pharmaceutical-grade beeswax and the highest quality damar resin. Paint manufacturers use an extensive roller system to mill the pigments to their smallest particle. The pigments are then evenly dispersed throughout the paint. Some artists like to make their own paint with oil paints or pigments to avoid the cost of working in encaustic. Most artists I know might make their own medium but prefer to purchase their paint to avoid the safety hazards of working with pigments or the difficulty of achieving the correct balance of oil to wax. Artists who purchase paint like the huge variety of colors available, the ability of purchasing consistent colors over time, the convenience of different sizes and the ease of having paint ready to go.

When encaustic paint is at the ideal temperature for use—175–200°F (79–93°C)—it is the consistency of rich cream.

OTHER BASIC EQUIPMENT

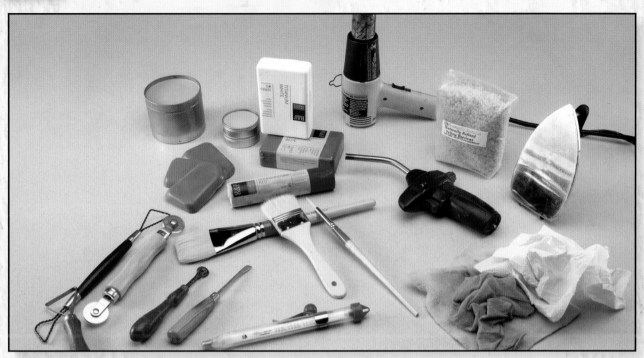

Equipment and materials you will need for encaustic painting include wax, medium, paints, mark-making tools, brushes, thermometers, heat tools and materials for buffing.

HOT PALLET: Commercial pallets made specifically for encaustic painting consist of an anodized aluminum base situated over a heat source. These offer the advantage of providing a surface for mixing paint directly on the pallet as in traditional painting. Some artists use kitchen appliances like a pancake griddle or electric skillet to heat their wax. Most kitchen appliances have unreliable rheostats, so get an additional surface thermometer to ensure your paint is at a safe temperature.

TOOLS: A variety of tools can be used for inscribing and texturing: dental and clay tools, printmaking and burnishing tools, razor blades, awls, nails … almost anything that can make a mark in the wax can be used as a tool.

BRUSHES: Any natural bristle brush can be used with encaustic, but once a brush is used with the wax, it cannot be used with any other medium. Most artists use a variety of inexpensive brushes and simply let them cool between paintings.

OTHER MATERIALS: Tuna cans, paper towels or rags, papers and fibers to collage, toner copies for transfers, oil sticks, pastels, watercolors, wood-burning tools: All of these items have a place in encaustic work. As you explore this exciting medium, you will find encaustic tools and materials everywhere you go.

Many artists like to use an electric fry pan as a medium vat.

Stick to inexpensive brushes because once they are used in wax they can't be used in any other medium.

BEFORE THE WAX

STARTING THE CONVERSATION

Handmade paper as a support for encaustic painting offers a world of options for creating an interesting underpainting. Any materials that make a mark on paper—pen and ink, pencil, crayon, oil pastel, stamps, watercolor—can be used to create imagery or color before the first layer of wax is applied. As subsequent layers of medium or transparent color are applied, the underpainting recedes into the background, adding to the luscious sense of depth.

Both encaustic and papermaking are two ancient art modalities with thousand-year histories, so it isn't surprising that both will want to have a voice in your work. My experience is that one or the other will dominate in every piece of art. Sometimes the paper is simply an interesting support for the wax. It may even be hard to detect any encaustic pigment. Other times the paper support becomes a finished piece without any wax at all. As an artist I try to facilitate a conversation between these two decidedly strong mediums.

I find it easier to begin the conversation with an underpainting. The translucency of the wax allows the viewer to see into and through these layers to what lies beneath. So, this is where. I begin. For underpaintings, you can pull out all of your "other" studio materials. Anything that you have used to work on paper in the past is fair game. Make marks … add color … stamp shapes. In other words, dive in!

 ← scan for bonus content

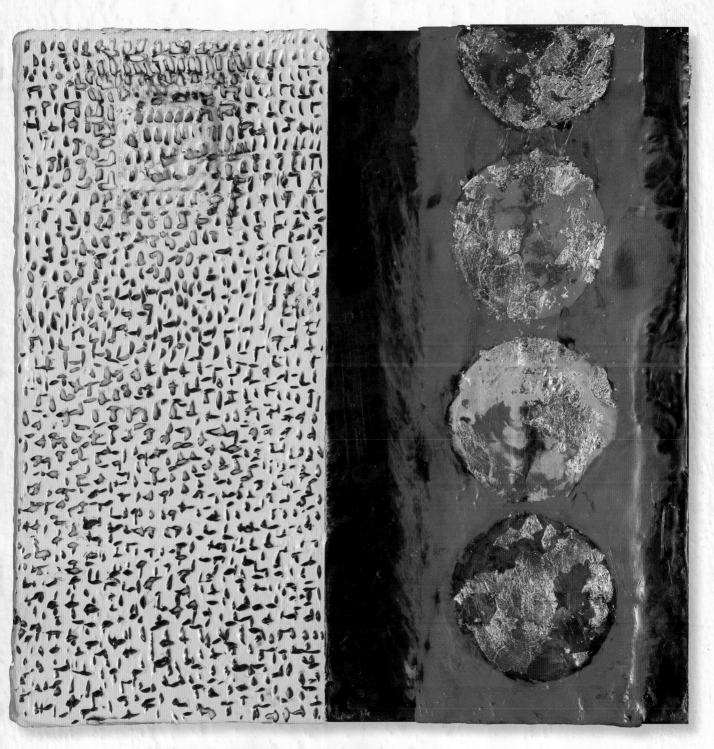

GALLERY: THE FOUR FACES OF EARTH

This is one piece where I used the sun to fuse the wax. I liked the way the dark under painting came forward and began to blend. The addition of gold leaf helped to balance the two distinct sides of the painting.

(cotton, abaca, pigmented beeswax, resin, gold leaf)

WORKING WET:
WATERCOLORS, INKS & COLLAGE

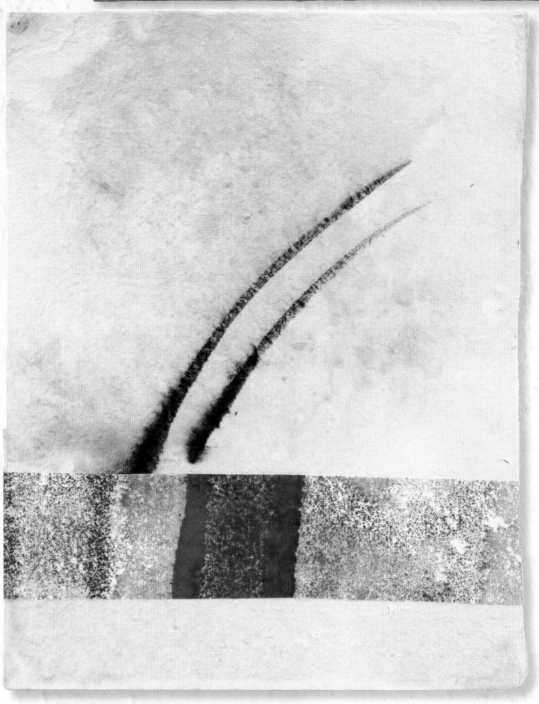

**STUDIO SAMPLE: DOWN TO GRANDMA'S HOUSE
(UNDERPAINTING)**
(cotton, abaca, watercolor, artist inks, collage paper)

WATERCOLORS AND INKS

One way to create an interesting background for wax is to use watercolor or ink on the wet paper. Because the cotton pulp has been made without sizing, it will be porous and will naturally spread the ink or watercolors. Try a variety of applications on a test sheet of wet paper to see which best meets your needs. Choose only lightfast inks that resist fading or watercolors for your serious work. Anything under the wax is archival, but the wax is not UV protected, so lightfastness is an archival concern.

MATERIALS

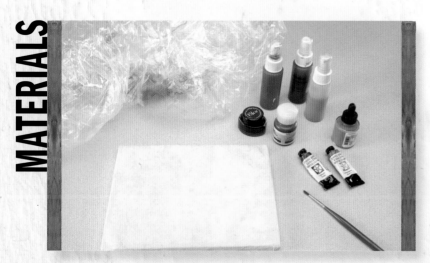

plastic protective sheeting

wet paper support

watercolors (liquid or cake)

small spray bottle

lightfast artist inks

CHOOSE A NEW OR FRESHLY MADE SUPPORT

It's possible to rewet a support that has already dried, but you will get the best effect if the wet processes are created on a freshly made sheet of paper. As the support dries, it will shrink evenly.Protect your space by laying down a sheet of plastic or unprinted newsprint. Do not use newspaper or colored paper as an underlayment because the wet paper will leach printer's ink or color from what is below.

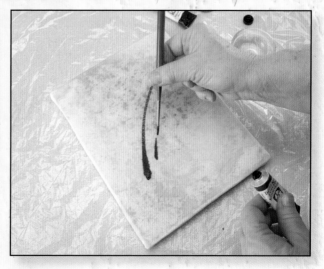

SPRAY BOTTLE APPLICATION

Add a few drops of concentrated liquid watercolor to a small spray bottle, like those sold for toiletries. Fill the bottle with water. Add more color to the bottle for a stronger value. Apply the paint using short, controlled pumps from the spray bottle. The higher you hold the bottle away from the support, the more diffused the spray will be. If you use several colors, they will naturally blend on the wet paper. Allow your paper support to dry completely.

DIRECT APPLICATION

Use the ink or liquid watercolor directly from the bottle for an intense and vibrant mark. You can use the bulb dropper that comes with most inks to add drops or other marks onto the paper. Use a paintbrush as an applicator for your images. Allow your paper support to dry completely.

COLLAGE

Unless you are working with very thick papers (100 gsm or more), you can easily collage paper onto a wet paper support using methylcellulose. The collaged element has a more natural appearance than if it were glued on or even collaged into the wax.

MATERIALS

plastic protective sheeting

wet paper support

methylcellulose

foam applicator

paper collage materials

spray bottle of water

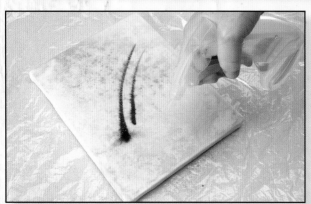

1 Spray the paper that you want to collage lightly with water. Let it sit for a few minutes to absorb the moisture.

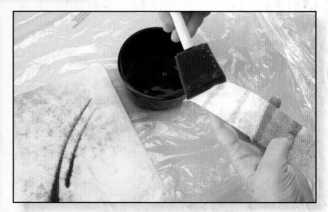

2 Apply methylcellulose to the back side of the collage element and to the area of the wet paper where it will be collaged.

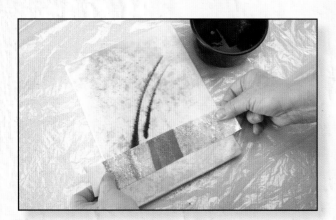

3 Glue down the collaged paper.

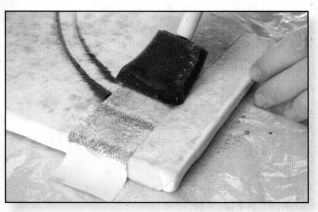

4 Apply a thin coat of methylcellulose over the collage to seal it to the wet paper. Allow the paper to dry completely.

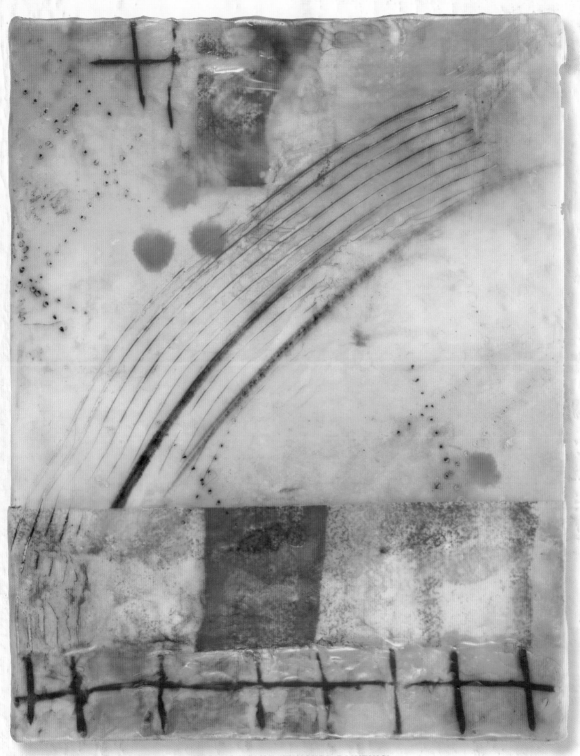

STUDIO SAMPLE: DOWN TO GRANDMA'S HOUSE (FINISHED PAINTING)
Notice how both the collage element and the original ink marks and watercolor areas (the underpainting) have receded into the background after layers of wax. When additional marks or information are applied in between layers of medium, those marks float above the original work.
(cotton, abaca, watercolor, artist inks, collage paper)

WORKING WET: RUST

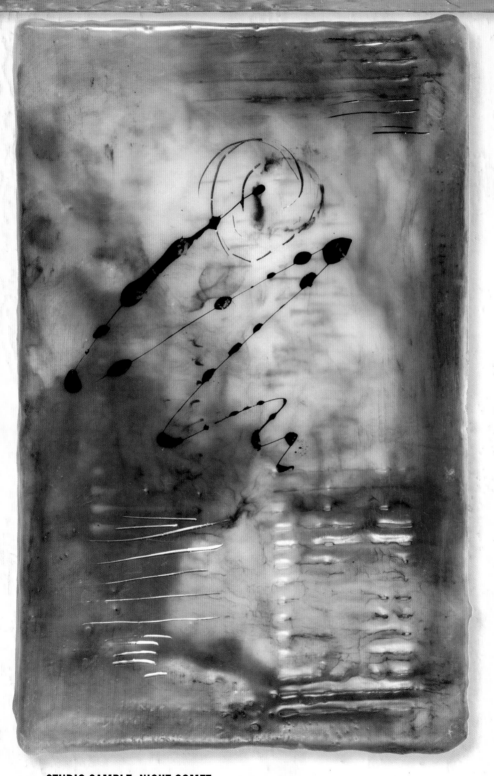

STUDIO SAMPLE: NIGHT COMET
(cotton, abaca, beeswax, resin, rust, ink, oil, bookbinding foil)

Rust (iron oxide) is known for its beautiful range of rich colors. It is chemically stable and lightfast, making it an interesting medium for applying color to wet paper. Salvage companies are great places to find interesting rusted metal shapes, especially if you look on the ground near an outdoor miscellaneous bin. They charge by the pound, so you are likely to walk away with a box of material for under five dollars.

Use a fresh, wet sheet of paper for this technique. Lay the sheet of paper on a layer of thin plastic. Dry cleaner bags work especially well. You can also use a wet wrapped or deckle support for this process, but I prefer to wait until I see how the rust turns out so I can arrange the paper on the support to best display the rusted images.

MATERIALS

thin plastic sheeting (such as a bag from the dry cleaner)

wet paper sheet

rusted metal objects (nuts, bolts, small metal pieces)

spray bottle of water

1 Carefully place rusted metal objects on the wet paper to create a design. Remember that the rust will transfer only at the points of contact. You might have a really unusual shape, but if it is bent in a way that it makes contact at only a couple of places, you will get a rust mark only at those locations.

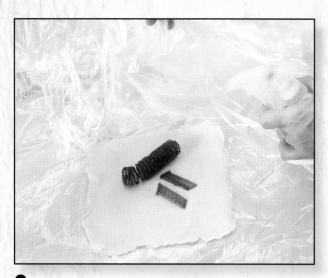

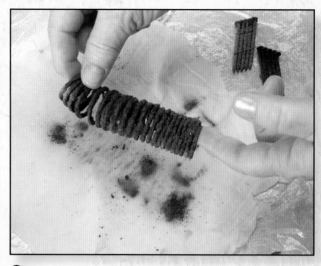

2 Cover the paper with plastic and spritz the paper daily with water to keep it moist so that the rust will transfer. The paper will need to sit for several days to get a good transfer of rust.

3 Remove the plastic and the rusted metal when you are satisfied with the transfer. Then wrap the paper around a foam core support and allow it to dry completely.

TIPS

- If you can't find rusted metal, you can rust your own with a little time and household materials. Fill a jar with water. Add a couple of teaspoons of salt, and the objects you want to rust. Seal the jar and wait a few weeks.

- Tin can be purchased from a craft store in flat sheets. It can be rusted easily with hydrogen peroxide (available at any drug store) and salt. This is a chemical process, so work only in a well-ventilated area. Pour some peroxide in a spray bottle. Mist the tin generously. While the peroxide is still wet, sprinkle on some salt. Allow the tin to dry completely. Remove the salt. Lay a wet sheet of paper over the rusted metal, cover with plastic wrap and allow the rust to transfer over time.

- Several rust-creating faux painting products can be found on the market. Most involve an application of a primer that contains iron oxide and an activator that begins the rusting process. These products allow you to rust any surface, even plastic or paper. Buy this product from a craft store or paint supply store.

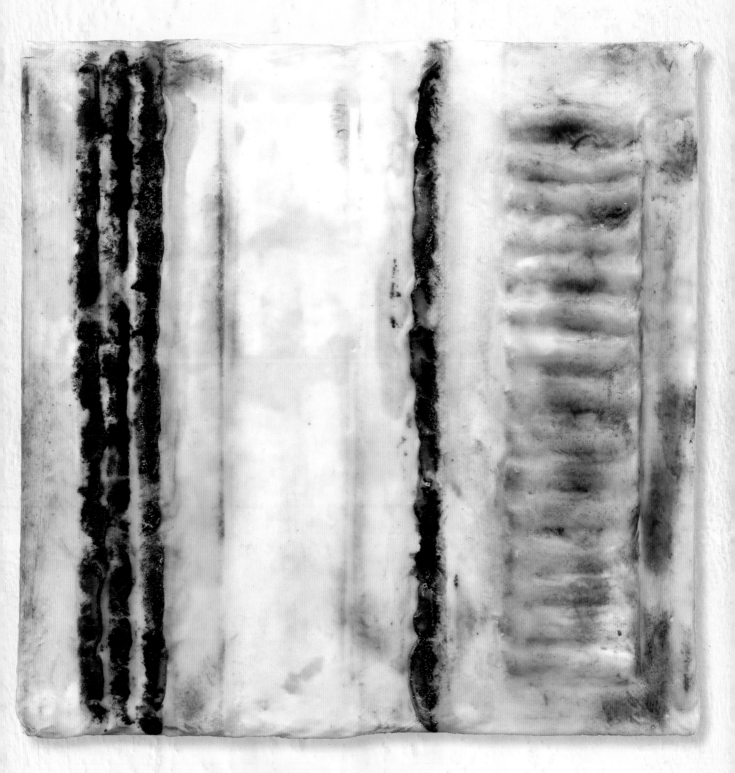

GALLERY: SPRING IS STILL ASLEEP
The interest in this piece was created almost entirely by using a dimensional support for the paper and by using a variety of wet and dry underpainting techniques described in this section, including screened on asphaltum, rust and torch.
(cotton, abaca, beeswax, resin, asphaltum, rust)

WORKING DRY: MIXED MEDIA

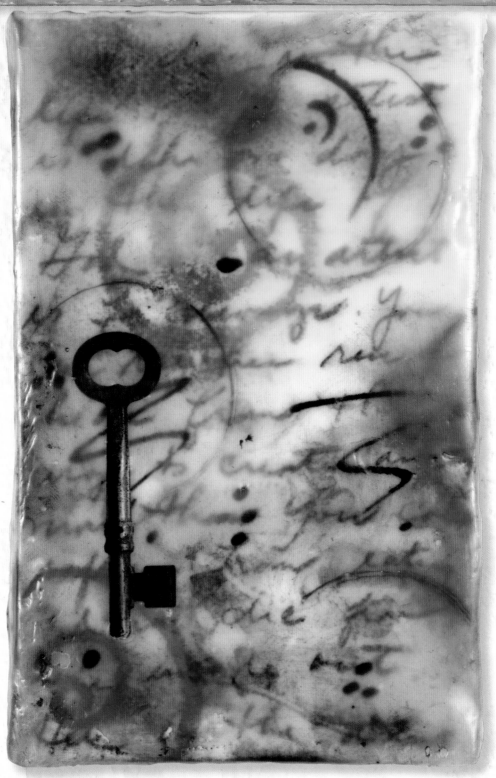

STUDIO SAMPLE: AMY'S DIARY
(cotton, abaca, beeswax, resin, graphite, oil, ink, collage)

For most people, early art endeavors are done on paper. You used pencils to write out stories on notepads. You colored with crayons in jumbo coloring books and added stamps to scrapbook pages. Although the forms you created in the first half of this book are a huge step from your Big Chief tablet, they are still essentially paper. And because they are paper, you can bring out the pencils, crayons, oils, pastels, graphite powders, markers, stamps and anything else you have in your studio that you have used in the past to make wonderful art.

MATERIALS

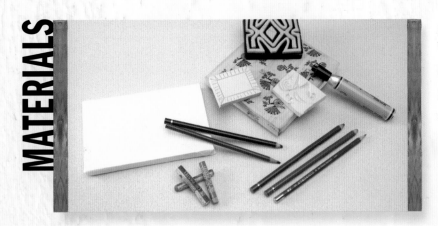

paper support (deckled or wrapped, with smooth front)

graphite

pencil colors

oil pastels

markers

stamps

other mark-making materials

1 Use any one of your dry paper supports that has little or no embossing and very little dimension. You will create interest through more traditional methods.

TIP

Save the glitz for the finishing work. If you use metallic markers, crayons or inks, you will lose any metallic effect when you apply the wax.

2 Draw marks, shapes and images on your canvas. Remember that this canvas be an underlayment to the wax and will be pushed back with every layer of medium or glaze so you need to be bold in your color application. If you add words or images that are crucial to the finished work, make sure they are are large enough to show through later on.

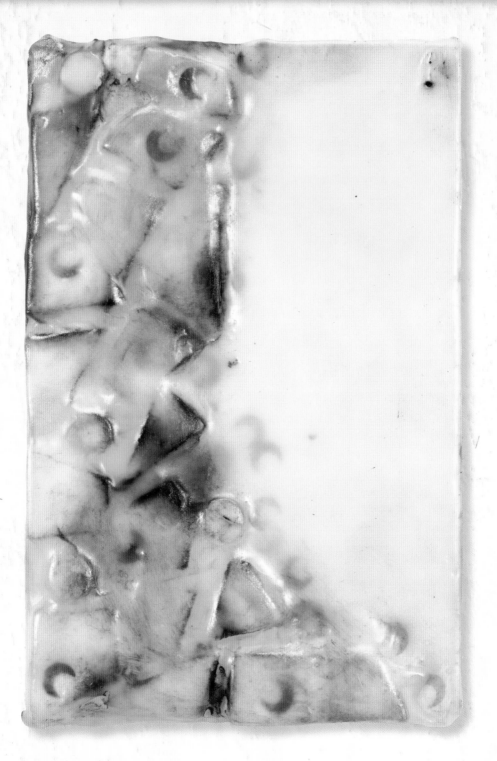

STUDIO SAMPLE: ROCK HOUSE
(cotton, abaca, beeswax, resin)

I have to thank Patricia Baldwin Seggebruch for encouraging me to set my paper on fire. A few years ago I hosted her visit to Texas for a foundations workshop. My expectation was that I would do the cooking and cleaning, help with the set up and perhaps play a little myself. I never thought the techniques she was demonstrating would apply to my paper.

But with her encouragement, I set a torch to the paper and loved the effect. I've been screening on grout and tar, rubbing in oil and burning shapes into the paper with heated metal ever since.

Warning: A propane torch is a potentially dangerous tool. Be sure that you read and understand the manufacturer's guidelines and instructions before you attempt this technique. You will NOT be burning the paper. Instead, think of this process as a way for the fire to scorch the paper or smoke the paper so that the lovely colors of the fire application can be used as an underpainting.

MATERIALS

dry wrapped paper dimensional support

torch

wood burner and rheostat

fire-retardant/heat-resistant surface

TIPS

- This process works best with a dimensional wrapped support. The deckle is probably the most likely place to catch fire and actually burn, so avoid your deckled paper for this technique.
- Be sure that you can hold the torch in one hand and your paper in the other. If the torch is too heavy or too awkward to manipulate the nozzle and hold the paper at the same time, elicit a friend's help. Have him hold the torch steady while you hold your paper support to the flame, moving it around until you get the desired effect.
- If your torch allows you to tip it toward the ground, then a good option is to put your paper on cement or fire safe bricks for torching, especially when the work is small.

SAFETY FIRST

- You will be using an open flame, so work with this technique outside and with a partner.

- In the event of fire, have a garden hose or container of water nearby. If the paper begins to burn, dip the burning edge into the water. Wait until it dries completely to continue. If the burn penetrates to the foam core or alligator board panel, you will need to discard your paper support. Avoid inhaling any smoke from burning foam core.

- Make sure that the torch is completely shut down after each burn.

- Wood burners should be plugged into a rheostat so that you can control the heat.

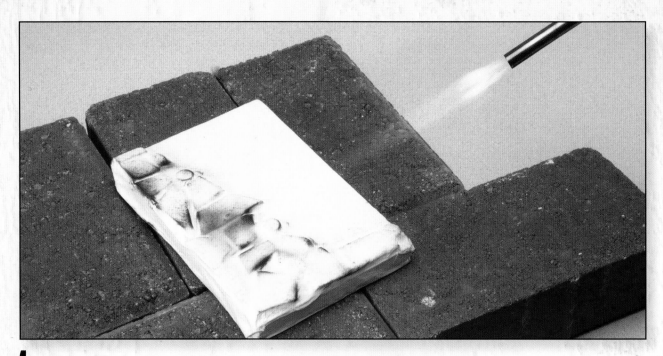

1 Using the torch at medium flame perpendicular to the paper, lightly run the fire over the dimensional areas of your support to highlight them. Use the torch as a shading tool, softening the outer edges of the piece or making marks of your choosing.

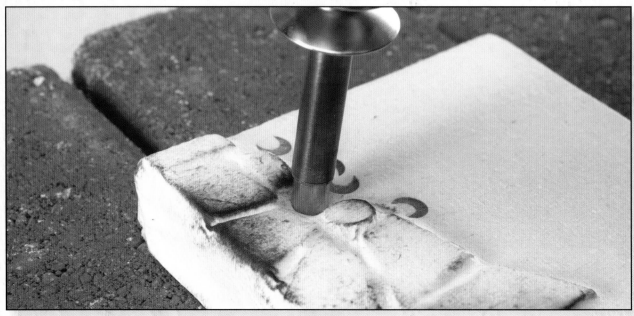

2 When the torch is shut down and the wood burner is heated to temperature, hold the wood burner to the paper where it will make marks with the heat. If you smell burning paper, that is a natural and nontoxic part of the process. Do not burn through the paper to the foam core support below. Styrofoam is toxic when burned.

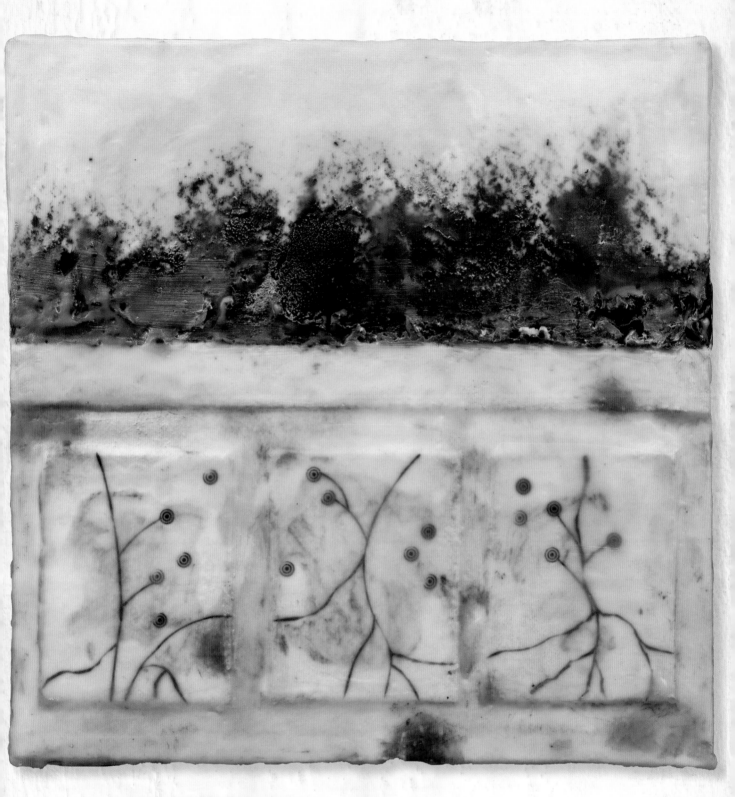

GALLERY: ROOTED DEEP

The paper on this work had been heavily torched to highlight the dimensionality of the support. I used an interesting circular head on a wood burning tool to create some of the shapes along with troweled on asphaltum. Layers of medium, some oil stick glazes and inlay lines complete the piece.
(cotton, abaca, beeswax, resin, asphaltum, oil)

WORKING DRY: TAR AND GROUT

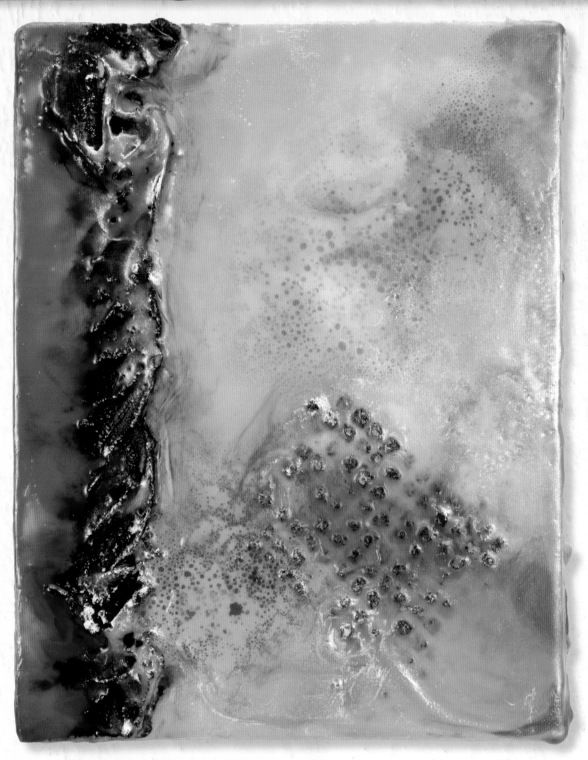

STUDIO SAMPLE: RED SKY IN MORNING
(cotton, abaca, beeswax, resin, tile grout, asphaltum, oil)

While you have created a variety of textural supports by embossing and adding inclusions and dimension, you might want to add another element to the paper. Asphaltum and grout are easy to screen and they dry hard and dimensional, adding interesting details to works on paper. Asphaltum is a black, cement-like mix used as an asphalt patch. It looks and feels like tar. Grout is a cement-like material used by tile setters. It comes in a wide variety of colors and consistencies and is fairly inexpensive. Since grout is often sold in large 25 lb. bags, it would be worth your while to ask neighbors and friends for grout they might have remaining from other projects. Both asphaltum and grout can be purchased at hardware stores.

You will not heat the asphalt or grout directly in this technique. Instead, you will cover the asphalt or grout with medium and fuse the wax into the paper, thereby merely exposing the asphalt or grout.

MATERIALS

grout (mix a small amount to manu-facturer's specifications)

asphalt patch

palette knife or flat trowel

protective plastic sheeting

screening material (drywall tape, punchinella, stencil)

newspaper

TIPS

- This process works best with a dry nondimensional support.

- Try toweling the textural material onto your support rather than screening for another effect.

- Wear gloves. Protect floors and worktables with plastic sheeting or newspaper. Wash all tools promptly in water. Discard the water outside. Work in well-ventilated areas.

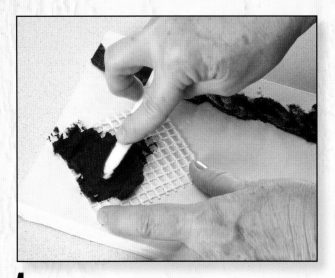

1 In a well-ventilated area, lay out a piece of newspaper larger than the size of your paper support. Place a screen onto a smooth flat area of the support. Using a trowel or large palette knife, lift out some of the material and screen it onto your paper.

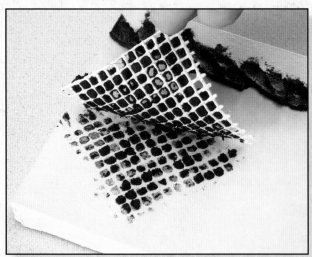

2 Remove the mask before the asphalt or grout dries. If you don't do this, your mask will likely end up being a permanent part of your piece! Then allow the support to dry thoroughly before applying wax.

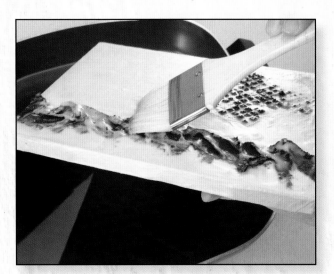

3 Apply at least two layers of wax to build up a solid layer.

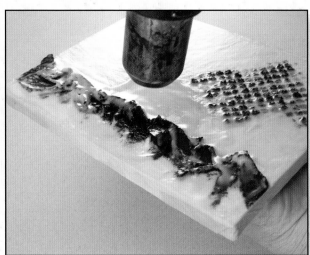

4 Fuse the wax. You might want to selectively fuse so that some of the asphalt peaks out of the wax and some areas remain covered.

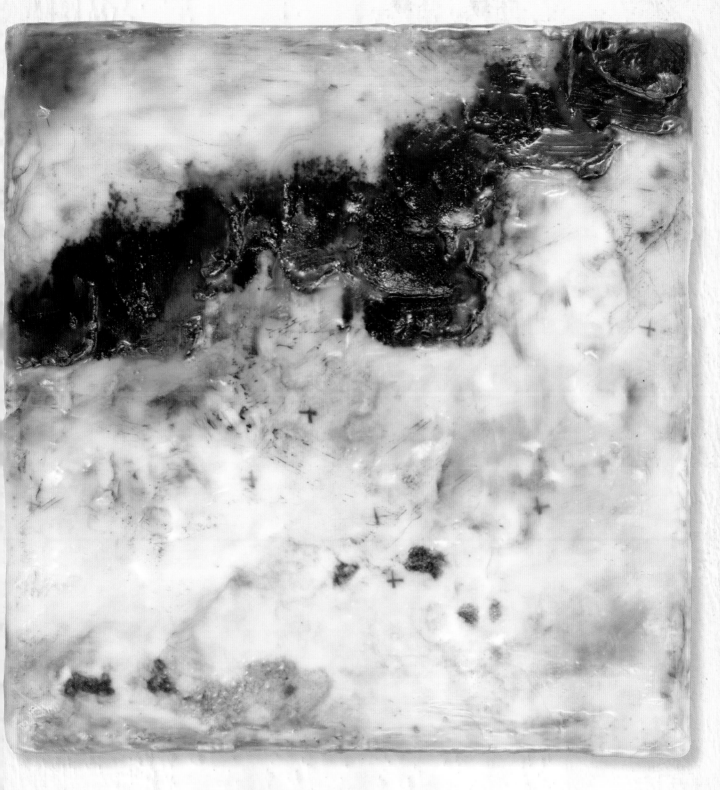

GALLERY: SHORELINE
In this piece the dimension of the asphalt is highlighted with a metallic
pigmented oil stick. The highlighting was added after the final application
of wax.
(*cotton, abaca, beeswax, tar, pigmented oil stick, graphite*)

ON THE WAX

TONE AND NUANCE

Now that you have fascinating works full of color and texture, you are ready for the wax. With these next techniques, you will shape the direction and feel of your art through layers upon layers of translucent color, marks and images in order to create art that is deep and luscious. Your orginal work will be pushed further into the background with every layer as it subtly grows and expands into something entirely new.

 ↤ scan for bonus content

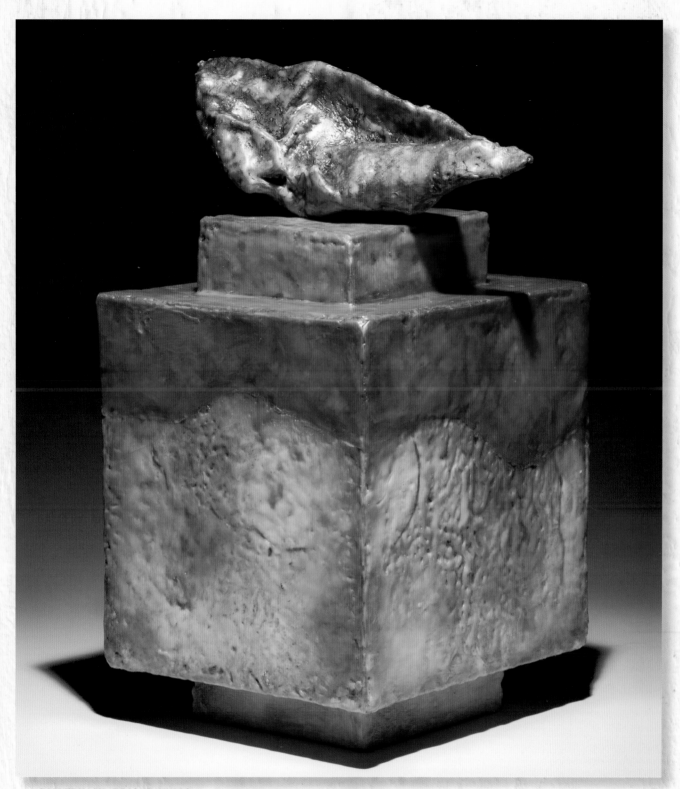

GALLERY: AH, BRIGHT WINGS

This sculpture was created using the processes described in the book. I rusted the paper and
wrapped it around a fully dimensional support. The depth in this piece comes from many
layers of pigmented oil between layers of medium.

(cotton, abaca, beeswax, resin, rust, torch, oil, plaster gauze)

PRIMING

If you have explored encaustic painting before, you know that the first two or three coats of wax serve as the ground on which to build your painting. If you are working on wood or panel, first heat the support and then paint a layer of liquid medium. After it cools a bit (loses its shine), paint a second layer and fuse it to the first layer with a heat gun.

When you're working with a paper support, especially one with dimension and texture, this first step will be done a little differently because the paper does not conduct heat. You can heat the support, but heating will only make the paper thirstier, and the medium will disappear into the thick paper. Once you have mastered this first step of priming a paper canvas, you can explore all of the traditional ways that encaustic artists work.

MATERIALS

dry support

heated medium

natural hair bristle brush

soft cloth or nylon stockings for buffing

TIP

The key to the first layers is to build up the wax slowly, using as few layers as possible to get an even coat of wax over the entire support. The more layers you use to get there, the more your original images will be clouded by the opacity of the wax. You will need additional layers for glazes, marks and imagery.

*Review the safety sidebars on the next page for information about safe temperatures for medium and proper ventilation of the studio.

1 Heat the medium to a liquid state. Brush a layer of medium over one of the dry paper supports you created in the paper studio. Let this support cool completely. I will often prepare several supports at one time so that I am not tempted to add a second layer of wax too soon.

2 Use a buffing cloth to shine the first layer.

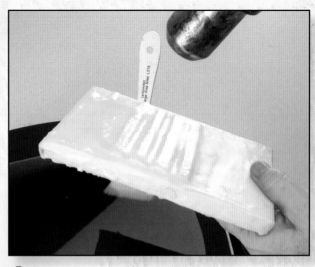

3 Add a second layer of wax over the first cooled layer.

4 Fuse lightly. For dimensional work, I use a heat gun. If you fuse too much, you will see dry spots on your canvas where the wax has been absorbed into the paper. Cool completely.

5 Repeat steps 3 and 4 until wax medium completely coats the paper.

SAFETY FIRST

Encaustic painting is a safe and nontoxic process if you follow two very important safety rules:

1 Heat your wax only to the melting point. For most medium recipes this means working between 175°F (80°C) and 200°F (93°C).

2 Work only in well-ventilated areas. If your studio has two windows, open both. In one window install a box fan to face the other open window. The height and positioning of the fan should be similar to the height of your palette or medium vat. Seal the area around the fan to insure that the wax fumes do not re-enter the space. If your workspace does not have at least two windows for ventilation, set up your encaustic studio in an outdoor area or seek expert help in achieving proper ventilation.

SAFE STUDIO PRACTICES

Following safe studio practices is a good habit for any artist. Most of these good habits apply not only to encaustic, but to any media:

- Have a fire extinguisher in your studio and know how to use it.
- Have an eyewash station nearby along with a first aid kit in case of spills or splashes.
- Wear clothing that protects you against burns.
- Wear gloves and/or barrier creams.
- Avoid eating or drinking in your studio.
- Be careful of working with solvents and always dispose of waste materials safely.

Use *The Artist's Complete Health and Safety Guide* by Monona Rossol for further information about safety regarding encaustic and other media.

GLAZING WITH WAX

A wax glaze is a transparent layer of pigmented wax medium. You can make a transparent glaze by melting a small amount of wax paint into a metal container such as a tuna can and adding enough medium to create the transparency you want. You can add wax glazes over the entire painting to change the hue slightly or over only a section of the painting to change the color of one area. Glazing adds depth to the work and is a process that is especially well suited to encaustic painting.

MATERIALS

dry support

heated medium

natural hair bristle brush

soft cloth nylon stockings for buffing

wax-paint glazes (2)

heat gun

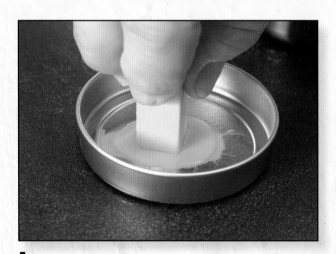

1 Make two glazes from colors that work well with one another when blended. Do not use complementary colors unless you want to dull the underpainting.

2 Paint a thin layer of the colored wax glaze onto a test sheet. If the glaze color is not deep enough, add more wax paint. If the color is too strong, add more medium.

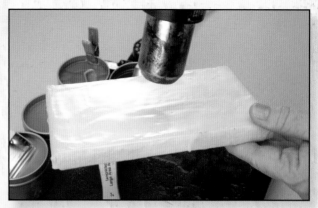

3 Warm the wax on the support using a heat gun.

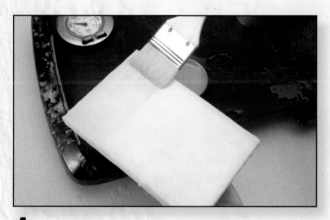

4 When the wax loses its shine, paint a layer of glaze onto the surface.

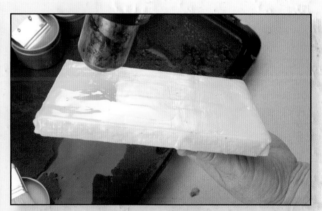

5 Fuse lightly. Allow to cool completely.

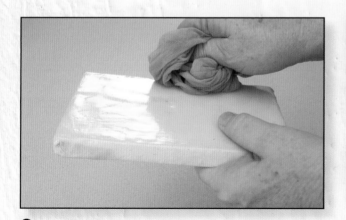

6 Buff to a shine with a soft cloth.

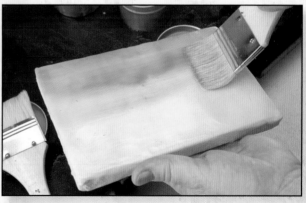

7 Repeat the process for the second color.

GLAZING WITH OIL

An oil glaze is similar to a wax glaze but has the advantage of adding color without adding physical depth, thereby allowing the underpainting to remain vibrant. A wax glaze distributes the color evenly over the entire painting, while an oil glaze emphasizes the natural texture of the work. In my own work I use both wax glazes and oil glazes to suit my purposes.

MATERIALS

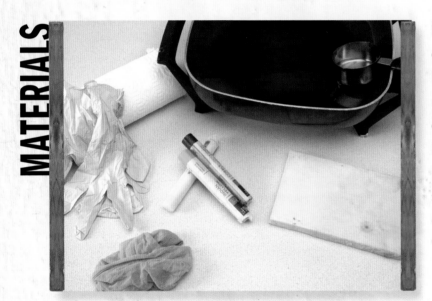

heat gun

dry support

heated medium

natural hair bristle brush

oil sticks or oil paint

latex gloves

paper towels

soft cloth nylon stockings for buffing

cooking oil or blender stick

SAFETY FIRST

- Linseed oil is found in R&F Pigment Sticks and in oil paint. It is highly flammable. Rags soaked with solvents and oil should be placed in a metal can with a lid and disposed of properly.

- Gloves are recommended for use with oil stick or paint application to ensure that any pigment particles do not enter the body through an abrasion on the hands.

- Do not use open flames around oil sticks.

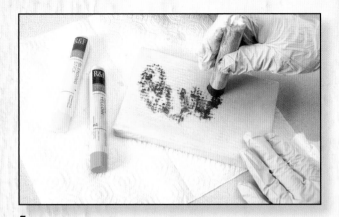

1 Use a primed support for this technique. Add color from a tube of translucent oil paint or an oil stick. You don't need much color.

2 With a gloved hand, distribute the oil paint over the entire surface of the waxed support, paying careful attention to the crevices.

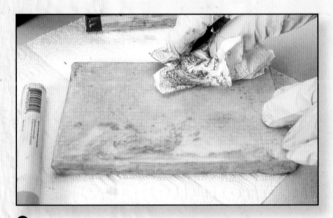

3 Use a paper towel or a soft cloth to remove as much of the oil from the surface as you want.

4 The towel will not remove all of the oil, so if you want the oil to remain only in the crevices and not on the surface, add a little cooking oil, linseed oil or petroleum jelly to the cloth. Or use a blender stick, as shown here.

5 Fuse lightly. Do not buff. A residue of oil will prevent a good buffing.

6 Add a thin layer of medium.

7 Fuse lightly. Allow the piece to cool completely.

8 Buff the cooled surface.

9 Repeat steps 1–8 with additional colors of oil, if desired.

TIPS

- A glaze will subtly inform the color beneath it. If you have a yellow glaze and paint a blue glaze over the yellow, you will get a green hue.

- You can create depth by adding a coat of medium in between glazing layers. From a cooled support, fuse lightly, paint, fuse, cool and buff.

- All wax oil sticks form a natural crust that needs to be broken before the oil stick can be used. Hold a paper towel over the tip of the oil stick and twist to remove its outer layer.

- You can use mark-making tools to scribe the wax. Draw, emboss or scratch the surface, then fill in the marks with oil stick or oil paint. Use a paper towel or soft cloth to wipe away the excess. Fuse lightly.

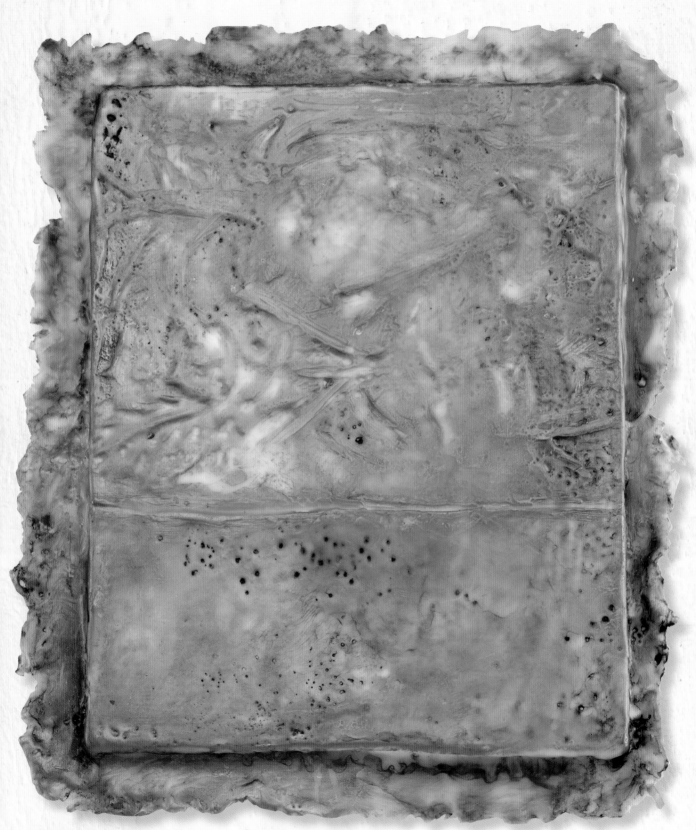

GALLERY: BEST DRESS
This work used embossed deckled paper onto a non-dimensional support. After priming the canvas, I applied a dark blue oil stick over the wax. The color was worked into all of the natural crevices and embossing of the paper. I wiped most of that color off and then began to layer with medium and toning oil stick colors.
(embossed paper with deckle, oil stick, powdered pigments)

GLAZING WITH ALCOHOL INKS

Alcohol inks offer a variety of applications, including glazing. Alcohol inks are highly pigmented paints suspended in alcohol. They are transparent by nature and can be further thinned with denatured alcohol. The glaze has a shiny appearance, so it's best done as one of the last steps to create a contrast to the wax.

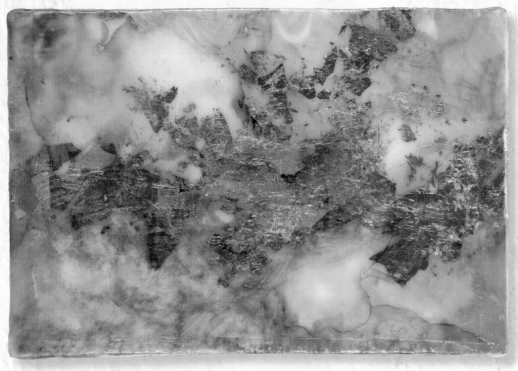

STUDIO SAMPLE: LOST IN THOUGHT
(cotton, abaca, beeswax, alcohol inks, gold and copper leaf)

MATERIALS

dry support

heated medium

natural hair bristle brush

paper towels

alcohol inks

scraping tool

soft cloth nylon stockings for buffing

heat gun

GLAZING

1 Squeeze some ink onto the wax. Here I am using two colors.

2 Use a paper towel to spread it along the surface. Inks set up as the alcohol dries, so work quickly.

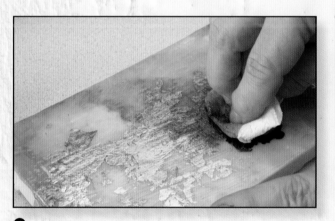

3 To create a completely even glaze, add the ink to the paper towel and use it to spread the color over the surface.

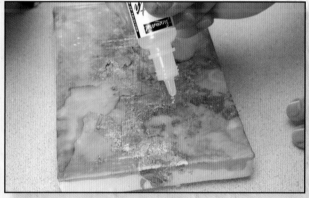

4 Produce a halo effect by adding a few drops of denatured alcohol directly to the surface of the wax.

5 Fuse lightly. Allow it to cool completely. Buff.

DIRECT PAINTING

I most often apply alcohol inks as one of the final layers of the work. I prefer to use oil sticks as a glazing medium and alcohol inks to add nuance to an area of the work that needs a punch. Applying the ink in a familiar painting process allows me greater control. The alcohol dries to a smooth, hard, shiny finish.

MATERIALS

dry support

heated medium

alcohol inks

watercolor well or palette

watercolor brush

heat gun

TIPS

- Use a primed support for this technique. Although alcohol inks are liquid, each brand will have a unique feel on the wax. I prefer Jacquard inks because I can get a better glaze.

- Stamp ink is just one of many alcohol-based art media. If you want to use rubber stamps to add imagery between layers, try using alcohol-based ink.

- Create interesting blending effects by adding a few drops of denatured alcohol to the surface.

- Alcohol inks yield an especially pretty effect when used with gold leaf. Wax alone will dull the glittery effect of gold leaf. The addition of alcohol inks helps preserve the leaf's luminescence.

1 Squeeze ink into a small watercolor well. Use a brush to paint an image directly on the wax. You can also use the nib on the bottle to paint directly onto the wax. As the alcohol evaporates, a layer of the ink will remain.

2 The ink must be fused into the wax after it dries.

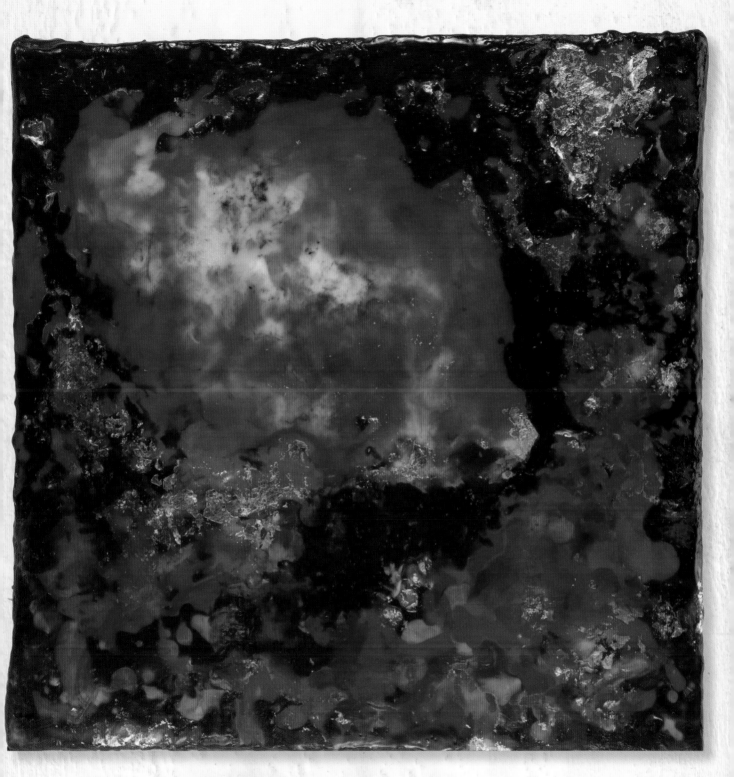

GALLERY: INFERNO

This piece was actually going nowhere for most of its creating life. I had the gold buried in composition and was hoping to reveal it in areas by scraping back. It wasn't until I began toning the revealed composition gold that it began to come together … and, happy accident! I discovered that while wax will dull metallic effect, the alcohol just nuances its color!

(cotton, abaca, beeswax, alcohol inks)

IN THE WAX

SUBJECT MATTER

You can great books written by leading encaustic artists detailing a variety of traditional and experimental encaustic techniques. Most, if not all, of these techniques will work with on your handmade paper supports. If you have followed the process from the beginning, you have already made many decisions regarding subject, from the inclusions that you put into the pulp to the marks and images you created in your work before the wax to the translucent layers of color you applied on the wax. This chapter outlines four techniques that you can use to add that final punch to the work.

 scan for bonus content

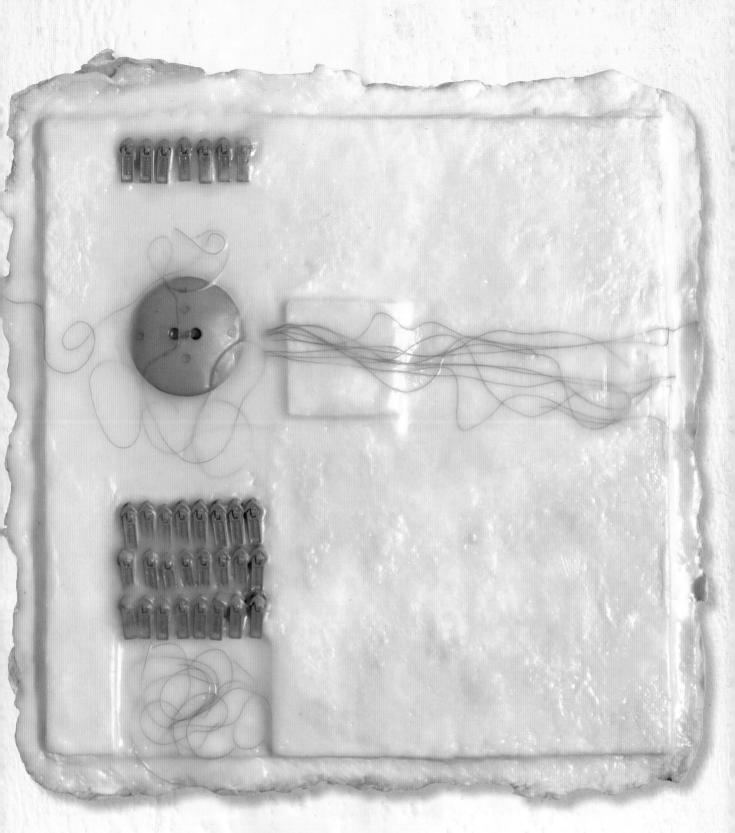

GALLERY: HAIR IN THE WIND
After embedding similarly colored threads, button and zipper hooks, I
realized it didn't want anything else.
(cotton, abaca, beeswax, resin, found buttons, zippers, threads)

INLAY

Wax is malleable and will take marks made with any sharp instrument: old dental tools, pottery tools, kitchen utensils, nails and other tools from your workshop, embossing tools and sticks and rocks. Inlay is a technique that comes from woodworking and jewelry. A mark is inscribed into the wax and then filled with an inlay, which in this case is a contrasting color of wax. When cool, any overfill is scraped back to reveal a beautiful clean line. When sandwiched between layers of medium, these lines or shapes seem to float.

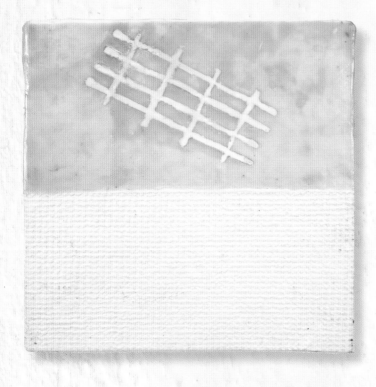

GALLERY: LANDSCAPE IN THE SNOW
(cotton, abaca, beeswax, resin)

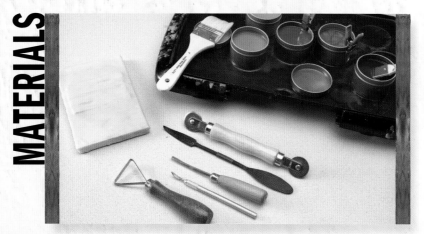

primed support

heated medium

natural hair bristle brush

mark-making tools

pigmented wax paint

scraping tool

1 With mark-making tools of your choice, create a channel on the surface of the wax. If the wax is warm, the marks will be deep and wide. If the wax is cool, the marks will generally be sharper and shallower. Linoleum or wood-cutting tools work best for this process because they are V-shaped, they come in a variety of widths and they make burr-free cuts that are easy to fill.

2 Choose an opaque encaustic paint and use a brush to fill the channel with liquid paint. Do not fuse. You will want to be able to scrape away any wax that spills over the incised line. Fusing at this stage will make it difficult to scrape back to the line. Allow the paint to cool completely.

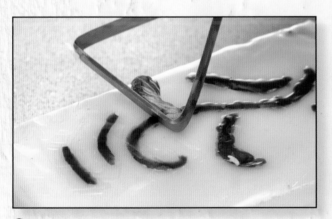

3 Using a razor blade or a pottery-scraping tool, scrape away any excess paint to reveal your original mark.

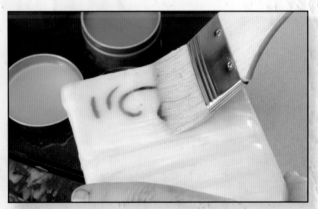

4 You can leave the line as it is, fuse it lightly to prevent bleeding or add a layer of medium over the line to protect it during fusing.

TIPS

- Use a support that has been primed with both an underpainting and a few coats of medium. If you have added glazes or layers of oil, make sure that the last layer is clear medium.

- Instead of making a mark with a tool, you can emboss warmed wax with something textural, like heavy lace or screening material. Fill in the embossed areas and scrape.

STUDIO SAMPLE: GOING IN CIRCLES
(cotton, abaca, beeswax, resin, toner-image transfer)

The technique of transferring an image from a toner copy offers a way to incorporate your own drawings or photographs into your encaustic work. Copyright infringement is always a concern. Although there are gray areas in the art world, I prefer to use my own imagery, even if my drawing abilities are somewhat inadequate. If you do use purchased imagery, be sure that the images are free to be used.

In my earlier work I found that transferring imagery was a hit or miss experience. Sometimes I was able to get a pretty good likeness; other times the image was damaged along the way. I learned a process from Gina Adams, in a workshop through R&F Handmade Paints, that is laborious but 100 percent effective. I have never since had an incomplete toner copy transfer. This process works the same with color or black-and-white toner copies.

MATERIALS

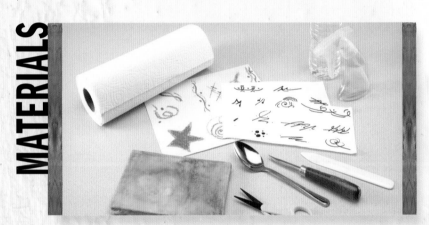

primed support

toner image in black and white or color

burnishing tool

spray water bottle

paper towels or rags

scissors

heat gun

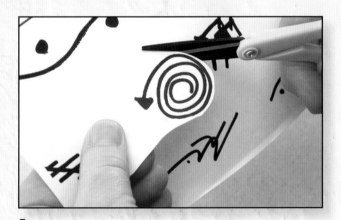

1 Cut out the image leaving about ¼" (6mm) of white paper all around the outer edge of the image.

TIPS

- Use a primed support for this process.

- Usually I add transfers toward the end of my layering process. It is a lot of work to get a good transfer, so I prefer that the image remains strong and visible through the wax.

- Make a toner copy of an image in either black and white or color. The copy can be either laser or photocopy toner. Feel free to use the cheapest grade paper available, even with a color copy.

- The support you use should be freshly fused (within a day) and cool. For best results, the copy should also be fresh, if possible.

- If you are using lettering or an image that you want to read exactly as you see it, use the mirror image mode on the copier.

2 Place the image face down on the wax. Use a burnishing tool (or the back of a metal spoon) to rub and apply pressure to the copy. To ensure that I get a good burnish, I will burnish twice in every direction. This is the first step in transferring the toner image from the paper to the wax. It's not possible to burnish too much.

3 Add a small amount of water to a sheet of paper towel so the towel becomes just damp. With the damp paper towel in one hand and the burnishing tool in the other, alternate between pressing the damp towel into the paper image and burnishing the image. If the paper towel is too wet, you will most likely tear the image as you burnish it.

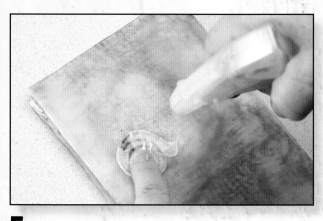

4 Continue this process, adding more water to the towel as necessary, until the paper begins to lift as you burnish. Make sure that all edges and areas of the image are lifting.

5 Add a little water onto the image and gently roll up the paper with your fingertips until all the paper is removed. You will see the transferred image. As it dries, you may find a light coating of paper residue.

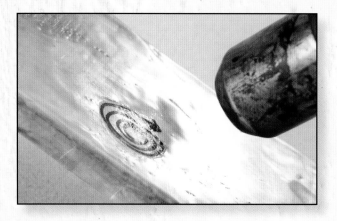

6 Fuse lightly to saturate the paper with wax. Add a protective layer of medium, if you desire.

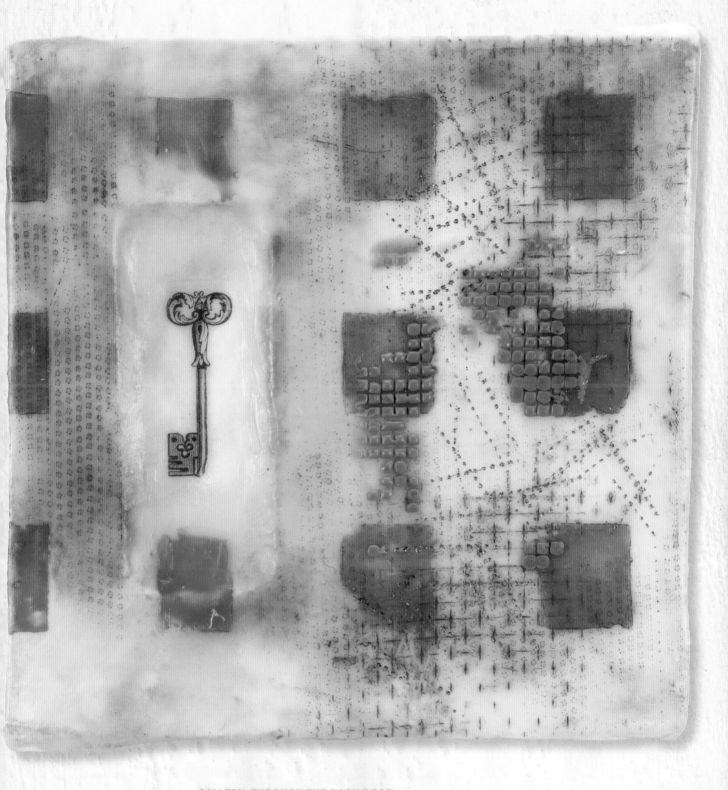

GALLERY: THROUGH THE BACK DOOR
*(handmade paper over foam core, watercolor,
encaustic glazes, screen collograph, stencil,
transfer, metallic transfer with tool)*

EMBOSSING IN WAX

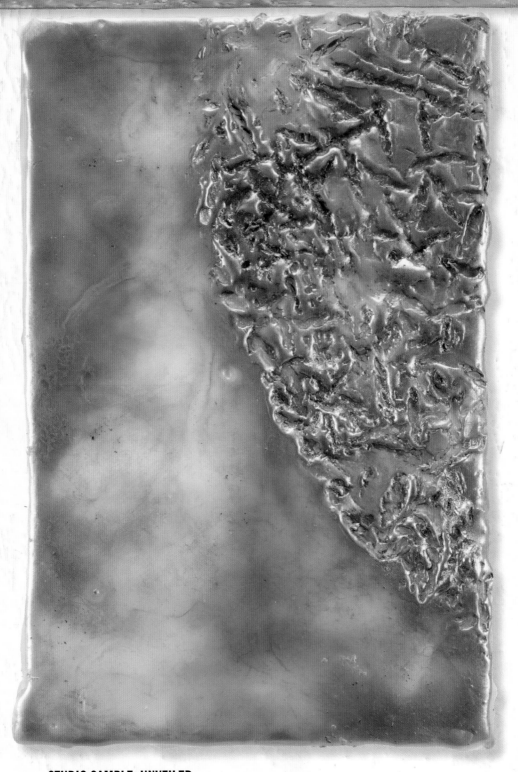

STUDIO SAMPLE: UNVEILED
(cotton, abaca, pigmented beeswax, resin, oil, bronzing powder)

Just as you were able to emboss your paper by placing screening or heavy lace onto it before it went into the press, you can also emboss the wax. You might emboss the wax to achieve a textural element or to provide a raised surface upon which to build wax accretions. Embossed paper under wax has a very different look and feel than wax embossed paper. Experiment with both processes to see which suits your work.

Because the wax must be warm to be embossed, some embossing materials that work well on paper do not work well on wax. Thick fabrics like jute, burlap or lace work especially well with wax but might discolor paper. Metals and plastics like screen, plastic craft canvas and wire work very well on paper, but they conduct heat so they mau be inappropraite for use with wax. In time you will find your favorite embossing materials for both paper and wax.

MATERIALS

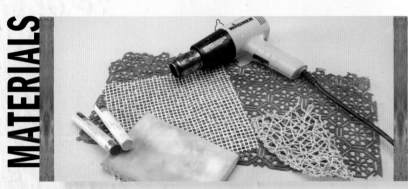

heavily waxed support prepared with medium or color

embossing materials (such as screening, cord, lace)

heat gun

oil stick

gloves

1 Fuse lightly to soften the wax.

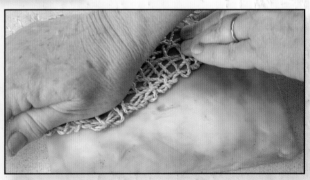

2 Emboss by pressing your chosen material into the heated wax. Let the wax cool.

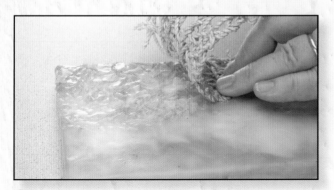

3 Peel the embossing material off the wax.

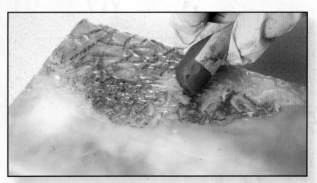

4 Use an oil stick to highlight the embossed area. Alternately, you can fill in the embossed texture using an inlay technique.

POURING AND EMBEDDING

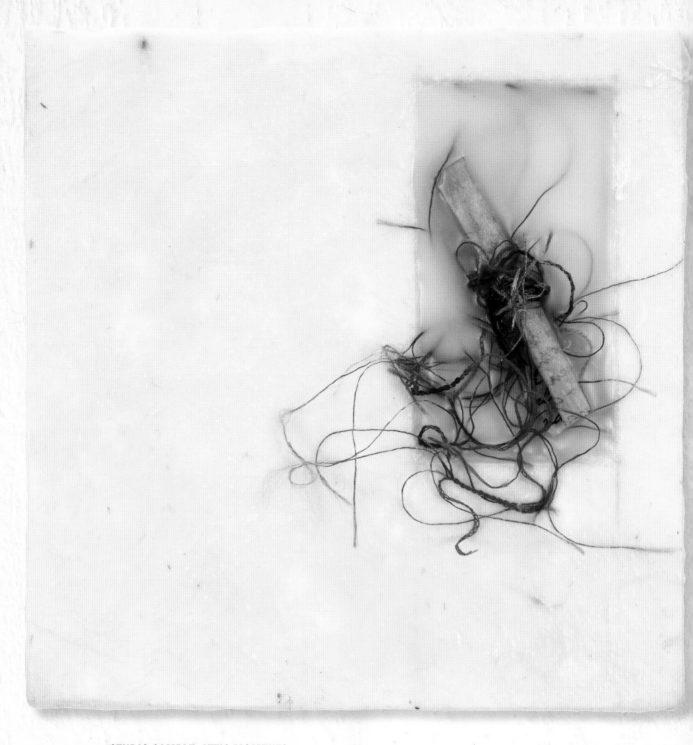

STUDIO SAMPLE: ATTIC MOMENTS
(cotton, abaca, beeswax, resin, thread, ephemera)

Sometimes the image that will make a final statement to your work is actually three-dimensional: a found object, an object from nature or something you have created. The best way to use these larger objects is to embed them in the wax. With handmade paper supports, you have the advantage of constructing a canvas with a well that's exactly the size of your found object.

MATERIALS

primed dimensional support with a window

heated medium

metal pouring container

object to embed

scraping tool

newspaper or wax paper

TO MAKE A SUPPORT WITH A WINDOW

To make a well for pouring, cut two exact size foam core supports. I often use ½" (13mm) foam core for my primary support and ³⁄₁₆" (4mm) foam core for my backing. From the primary support, cut out a window large enough for the object you want to embed. Glue on the backing support with gel medium and allow to dry completely. Make a sheet of paper, wrap and prime the canvas as demonstrated in earlier processes.

1 Place your support on a table protected by newspaper or wax paper. Check the table with a level to make sure your pour will be even. Pour medium from your medium vat into a metal container that can hold as much wax as you will need to fill the window. Pour the medium into the window in one continuous pour.

2 Embed the object in the wax before the wax sets up.
Allow the support to cool completely before you move it.

3 If wax overflows the window, scrape it off with a scraping
tool. Finish the work with any of the techniques you
learned in this book.

GALLERY: THREADS

I decided to pour and embed the spools of thread as an afterthought, so I had
not prepared my support with a well. To accommodate a pouring of liquid
wax, I made a dam at each end with tape before I poured.
(cotton, abaca, beeswax, resin, spools of thread)

GALLERY OF ARTISTS

Not all of the artists I have selected for the gallery portion of this book make their own paper or even work with handmade paper; however, all of them are working with paper in exciting and surprising ways. I've selected these eight artists because they each represent a different wax and paper process and because their unique perspectives on these two mediums will inspire you to think outside the box for your own work.

TRACEY ADAMS is a printmaker by training. Using wax in a monotype process, she prints on Japanese paper large enough to allow the viewer to float in between her beautiful room-sized installations.

DEBORAH KAPOOR allows the paper and wax equal voice in her fascinating sculptural work. She surprises us with the shape and whimsy that the paper provides and invites us more deeply into the work through her wax processes.

CATHERINE NASH has been, as she says, "a papermaker forever." Wax is her medium of choice for adding translucency to the paper, and for further enhancing the visual fragility of her work.

MARY MAYNOR is another longtime papermaker drawn to wax for the additional dimension it brings to her paper. She creates bookshelves of sorts for her miniature books, using the same types of processes outlined in this book and taking "support" to an entirely new level.

SUSAN STOVER uses paper more traditionally as a painting surface. She has been able to achieve amazingly deep, rich surfaces using microthin layers of wax and imagery.

RODNEY THOMPSON prefers papers that are found as a part of daily life. His work transforms used coffee filters, tea bags and found papers into ethereal objects of meditation.

HALEY NAGY challenges our notions of paper, wax and books. She combines these three humble elements into intriguing sculptural forms that can move and interact with an audience in delightful ways.

MILISA GALAZZI works with paper by removing it. The thin, flowing lines of her work, strengthened by wax, draw the viewer's attention to the negative space, the shadows and the delicate stitching that make up these floating drawings.

Many more artists' work is equally inspiring, but they are treasures for you to discover and enjoy on your own. For now, let these eight magicians in paper and wax inspire you to begin your own journey with these two ancient mediums.

 ⏎ scan for bonus content

TRACEY ADAMS

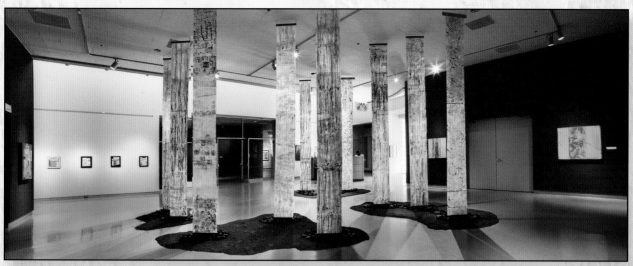

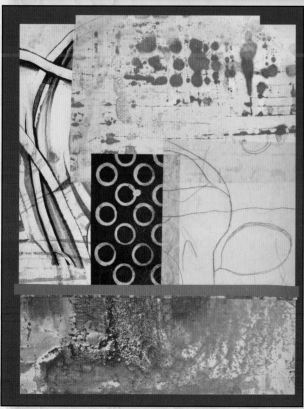

Tracey Adams

Tracey Adams's early love of paper led her to pursue graduate course work in printmaking and drawing from the School of the Museum of Fine Arts in Boston. Fascinated by the translucency of the wax on paper, she began working with encaustic paint in the late 1990s. After several years of painting on panels, Adams combined printmaking and encaustic, using bits and pieces of earlier etchings as collage elements in the wax. Drawn by the magic and spontaneity of creating monotypes from etching ink, she began to use pigmented wax like printing ink to create encaustic monotypes. Since 2007, Tracey Adams has been printing with painted wax on rolls of translucent Japanese paper. These scrolls are hung in room-sized installations.

DEBORAH KAPOOR

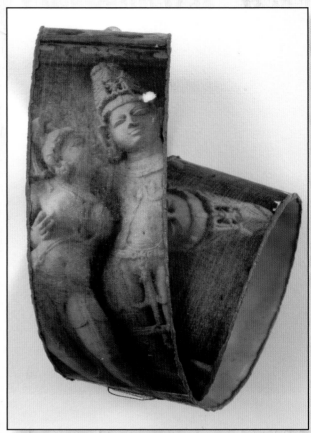

Deborah Kapoor

Deborah Kapoor studied photography as an undergraduate and painting/drawing in her MFA program at the University of Delaware. Much of her work today, however, is sculptural. Perhaps influenced by the work of sculptors with whom she shared studio space over the years, Kapoor understands that people are less intimidated when they encounter sculpture. In her work she chooses paper, which is lightweight both physically and psychologically, to create mass and form. Wax adds a flexibility and freedom that traditional paint does not. Her new work plays with the dimensionality of paper while addressing the issues of encaustic surface. Having rediscovered photographic gems from the past in a studio remodel, Kapoor plans to print and add more photo-based work to her sculptures.

CATHERINE NASH

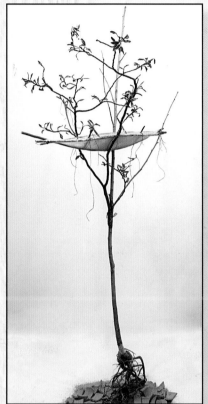

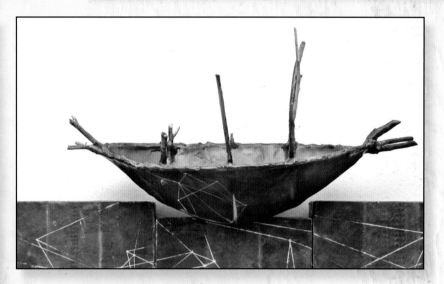

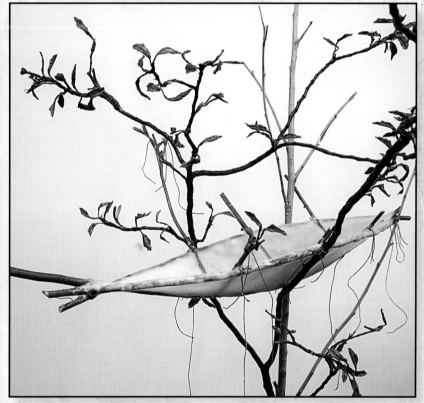

Catherine Nash

Before, during and after her BFA in printmaking and drawing and her MFA in mixed media, Catherine Nash lived in Europe and Japan and studied traditional and contemporary Japanese and Western papermaking and woodblock printing. As early as 1993, she began exploring beeswax as a way to heighten the value and luminosity of her work on paper. Nash has been drawn to the translucency and strength of wax on paper because it is in itself a reference to nature and the fragility of life. She has been working with a technique, created by Winifred Lutz, that casts organic materials in the paper. These sculptures are often completely encased in wax or saturated with just enough wax to allow the unique fiber surface to remain visibly transparent. In her work, Nash references roots and leaves as testimony to the resiliency of nature to survive, a celebration of the power of nature to heal itself and begin new growth.

MARY MAYNOR

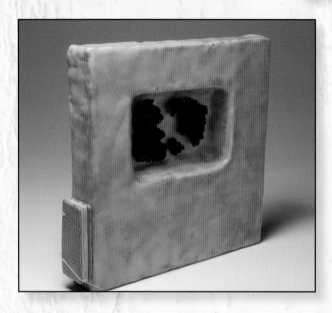

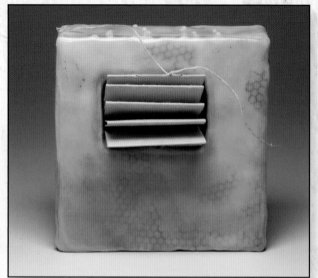

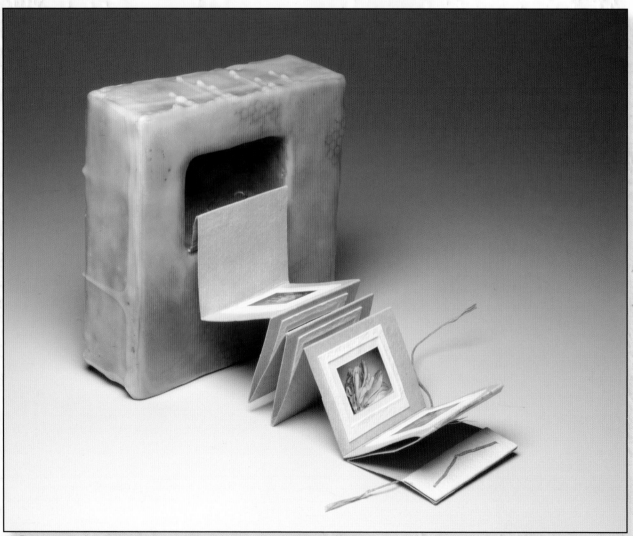

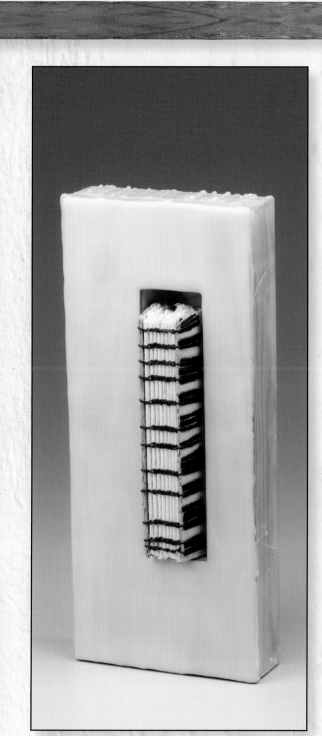

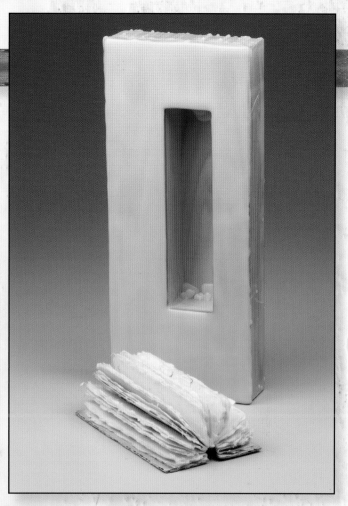

Mary Maynor

Mary Maynor has been a papermaker for almost twenty years, during which she has studied many areas of Western and Japanese papermaking. The paper led her into related arts of letterpress and bookbinding, studying at the Art Institute of San Antonio, Flatbed Press and the Southwest School of Art. She encases her paper in miniature artists' books, which are often embellished with polymer and precious metal clays. Maynor has recently begun to explore wax for the strength it provides to the paper. She creates encaustic paintings as both a backdrop and a home for her books. Her latest work is taking the language of the book even further into new sculptural forms.

SUSAN STOVER

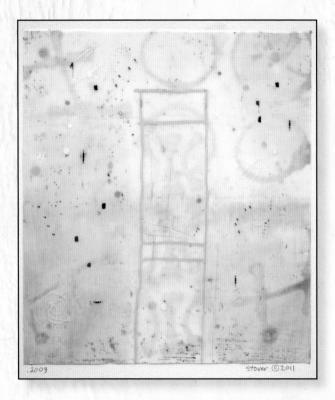

Susan Stover

Susan Stover started out as a painter but along the way discovered textiles. During graduate school, she concentrated her studies in woven and constructed textiles, developing complex patterns with computerized weaving. Tired of the limitations of the loom, she came back to painting in 2006, this time with an interest in encaustic paint. Although Stover used paper as a collage element early in her explorations, she began using it as a support for larger works in recent years. She discovered that by working in very thin transparent layers on paper, she could enhance the illusion of depth without adding physical dimension to the work. Throughout her artistic career, her love of pattern, texture, mark-making and a strong relationship with painting reamin consistent.

RODNEY THOMPSON

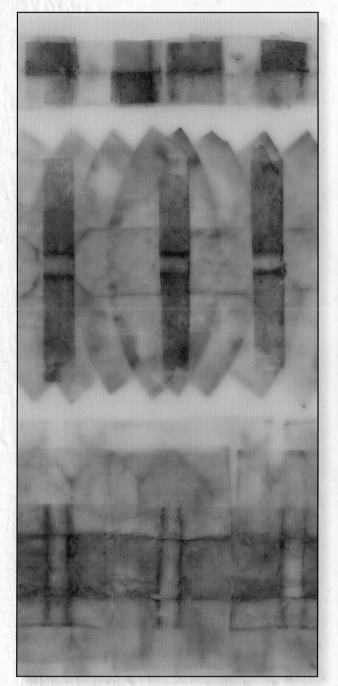

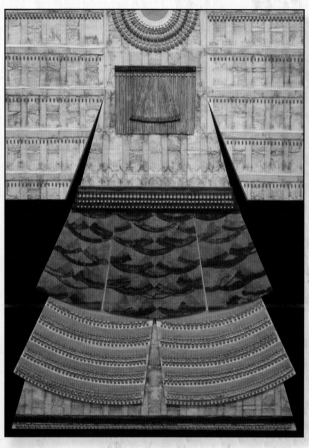

Rodney Thompson

Rodney Thompson is interested in the beauty of discarded and overlooked objects in everyday life. His imagery evokes a sense of calm and serenity. Although he has a collection of fine art and exotic papers, his favorite papers are those that are a part of daily life, such as used tea bags and coffee filters. In 2001, Thompson became interested in using wax as a way to incorporate interesting papers in his work. Over the years he has continued to explore the translucency of paper and wax and its ability to reveal marks or objects underneath and with the natural intensity of overlapped papers. His newest work incorporates naturally colored earth and rust along with his found papers.

HALEY NAGY

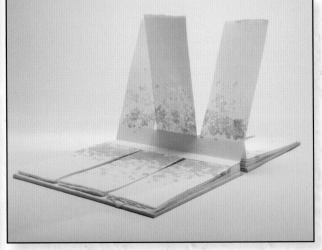

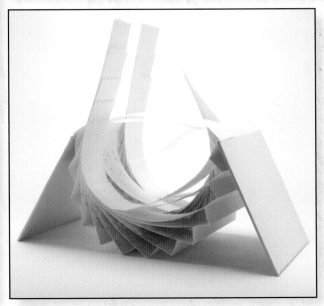

Haley Nagy

Since studying hand-papermaking at Columbia College Chicago, Haley Nagy no longer thinks of paper as the substrate for her work but rather as an integral part of the concept itself, with inherited meaning and historical connotations. She has come to use wax in her work on paper because in it she often finds a solution to an artistic problem. The inherent qualities of the wax—translucency, texture and light—enhance the meaning of the work. Her book *Illuminations* is a flag book, comprised of densely fused encaustic and handmade paper laminations. The process of "reading" this highly sculptural book transforms the work into an exploration of reader-book interaction. This work is also an abstract and personal exploration of the "great silence of God."

MILISA GALAZZI

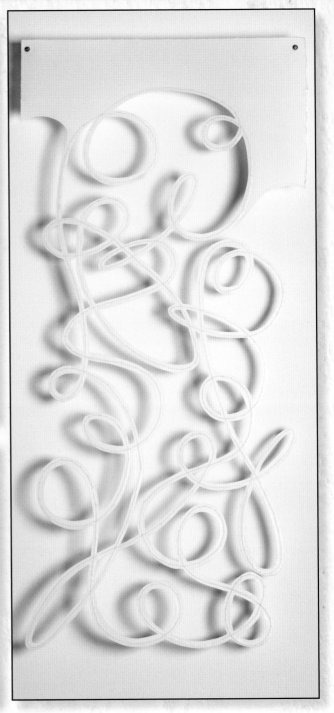

Milisa Galazzi

Although Milisa Galazzi is formally trained in a variety of art disciplines, paper has remained a constant in her work. She has used found paper in large-scale installations and commercial papers in smaller encaustic paintings. Her newest body of work involves hand sewing watercolor paper into intricate patterns and then cutting away the negative spaces to create a form of "paper lace." Galazzi appreciates the quality of protection the wax provides to the paper. Her work is about a connection to the past through objects, so the wax acts as a way to preserve these physical connections. For her, the wax also adds an element of visual layering that supports the notion of time passing.

GLOSSARY OF TERMS

When I first began teaching my workshops in paper and wax, I became aware of the technical jargon associated with paper-making and encaustic painting. When it became clear that my workshops were going to become a book, my students told me that a glossary of terms would be essential. I've tried to provide ongoing definitions for terms in this book in describing materials or processes, but I expect that you might have had to refer back to this glossary on occasion. I am hoping that this introduction to paper and encaustic will lead you to additional reading in each of these modalities. If so, this glossary of terms will be helpful.

BEATING: The procedure of softening the plant fibers into pulp using either a mechanical or a physical process.

BEESWAX: Natural wax from the honeybee, characterized by pleasant fragrance and soft, malleable surface. Filtered beeswax is white in color. Unfiltered beeswax is yellow. It's the primary ingredient in encaustic paint.

BLOOM: A whitish film that appears on the surface of an encaustic painting created when the wax is exposed to extreme cold. Adding damar resin to the wax helps prevent bloom.

CAST PAPER: A sculptural term describing the duplication of an object by pouring pulp into a mold.

CELLULOSE: A carbohydrate found in plant fibers.

COUCH: The action of transferring newly formed sheets of paper from the mould to a felt in preparation for pressing.

DAMAR: A naturally occurring tree resin added to beeswax to create medium.

DECKLE EDGE: The slightly wavy line created when a thin line of pulp seeps under the deckle in the paper-forming process.

EMBOSSING: A printing term used in papermaking to describe a raised or textured surface made when a textural mat is applied to the wet paper during the press.

ENCAUSTIC: Coming from the Greek *enkaustikos*, which means "to burn in," referring to the process of fusing layers of wax during the painting process.

FELT: A material woven either from cotton or wool onto which is placed a wet sheet of paper.

FIBER: A thread-like cellulose substance that when pressed together forms paper.

FUSING: A process of heating to melt each layer of wax to the one beneath .

GROUND: The painting surface.

LINTER: Pre-beaten and lightly pressed pulp that can be purchased and constituted.

MEDIUM: The vehicle for pigments in creating paint.

MELTING POINT: The temperature at which wax paint or medium melts.

MOULD AND DECKLE: The piece of equipment used for forming a sheet of paper from pulp. The mould is the screened frame that sits on the bottom. The deckle is the unscreened frame that sits on top. A dip mould is held together by hand. A pour mould is made to fit together snuggly.

PIGMENT: A finely powdered coloring material used to create paint.

POST: A stack of wet paper resting on felt layers in the press.

PULP: Boiled and beaten plant fibers that are ready for forming paper.

SIZING: A substance added to pulp or painted onto a pressed sheet of paper that retards the rate at which the paper absorbs ink or color.

SUBSTRATE: The support upon which the painter will paint.

APPENDIX I: MAKING MOULDS AND DECKLES

MAKING A DIP MOULD AND DECKLE

MATERIALS

wood picture frames (2) with one flat side

wood glue

staple gun with rust-proof staples

aluminum screen mesh (30–60 wires per inch)

polyurethane

1 Select two picture frames that are the same size. Identical frames work best. The inner dimension of the frame will be the size of the finished sheet of paper. Be sure that the size fits in your pulp vat and that you have enough room to dip the frame into the vat. Remove any glass or cardboard backing and any framing hardware.

2 Fill in any gaps in the frames with wood glue. Allow the glue to dry thoroughly.

3 Cut a piece of window screen 1" (25mm) larger than the outside of the frame. Pull the screen across the top of one frame and staple it in place. Only one frame will be screened.

4 Wrap the excess screen around the sides of the frame and staple it in place to make sure there is no gap between the screen and frame. A coat of wood glue over the area where the screen meets the wood frame will act as an additional seal. Waterproofing any exposed wood with polyurethane will extend the life of your mould and deckle.

MAKING A POUR MOULD AND DECKLE

fence wire equal to the size of your frame

aluminum screen mesh (30–60 wires per inch)

commercial deep frame

two heavy-duty rubber bands

two rus-proof screws

heavy-duty shears

roll of light gauge wire

1 Cut the fence wire to the size of the back of your frame.

2 Cut the aluminum screen mesh 1" (25mm) larger than the fence wire. Wrap the aluminum mesh around the fence wire. Secure it by sewing or wrapping it with a light-gauge wire.

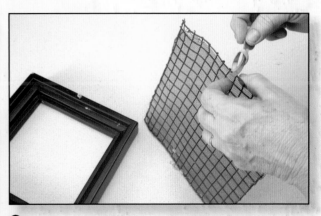

3 Attach a rubber band to either side of the fence wire by tying a knot.

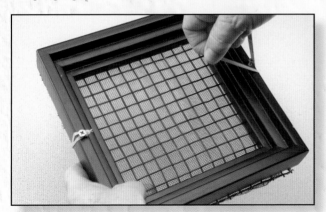

4 Attach two screws to either side of the frame to match the location of the rubber bands.

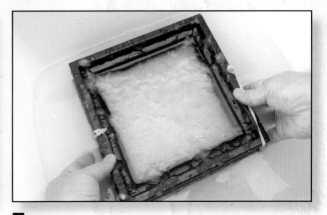

5 When using the pour mould, attach the wire frame to the wooden frame by way of the rubber bands. Add enough water in a plastic tub so that the mould and deckle is partially submerged. Add pulp to the frame. Agitate by hand. Lift the mould and deckle to drain. Remove the deckle and couch the paper for pressing.

 ## MEDIUM RECIPE

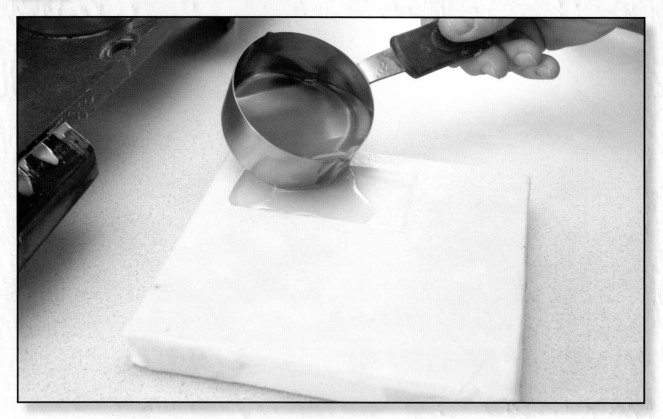

MATERIALS

1 lb. (453g) of damar resin (not damar varnish)

5–8 lbs. (2.3kg–3.6kg) of beeswax (filtered or unfiltered)*

length of natural silkscreen material

metal colander

zip-top freezer bag (quart)

silicone molds for cakes, cupcakes or bread

hammer

wooden spoon

electric deep fryer or skillet or crock pot

large metal pot

clips to hold silkscreen to colander

candy thermometer

metal dipper

scraping tool

* For harder finished surfaces, use 5 lbs. (2.3kg) of wax to 1 lb. (453g) of damar. If you are working on paper supports, you can use as much as 8 lbs. (3.6kg) of beeswax to 1 lb. (453g) of damar. Over time and with experimentation you will discover which ratio works best for your technique. Do not go lower than 4 lbs. (1.8kg) of wax to 1 lb. (453g) of damar or higher than 9 lbs. (4.1kg) of wax to 1 lb. (453g) of damar.

1 In a well-ventilated room, pour the beeswax into your heating unit (deep fryer, etc.). Set the temperature to 185–190°F (85–88°C). Put the candy thermometer into the wax to get an accurate reading. Stir as needed with a wooden spoon. Allow the wax to melt entirely.

2 Take 1 lb. (453g) of damar and place it in a sturdy plastic bag. Using a hammer, pulverize the damar crystals. After the wax is completely melted, add the damar and stir. Turn up the temperature to 220° (104°C). The damar will become gooey, but it will eventually melt down. Stir occasionally.

3 While the beeswax/damar mixture is melting, cut a piece of silkscreen material to fit loosely over the metal colander. Clip the silkscreen to the colander on all sides and set out the dipper and molds.

4 When the beeswax/damar mixture has completely melted, unplug the equipment and ladle the mixture through the silkscreen strainer and into the metal container. You can keep the wax liquid by setting the container on top of a warm griddle. Continue to ladle the mixture until you are able to pour the remainder through the silkscreened strainer and colander. This process strains out the wood debris found in the damar.

5 Once the mixture has been strained, remove the colander and ladle the strained medium into waiting silicone molds. If you use medium in small containers on your palette, you might want to use smaller cupcake-sized molds. If you use medium primarily in an electric skillet, then using cake or bread molds is a better option.

6 Allow your medium to cool completely before removing it from the molds. If there is still some sediment at the bottom of the medium, you can use a scraping tool to remove the debris. Wrap your medium in wax paper for storage.

TIPS

• There is no need to clean your materials. Store them together for another day.

• If you are using a larger ratio of damar to wax (such as 1:8), you might have to divide the wax and damar into two batches so that you will not overflow your heating container.

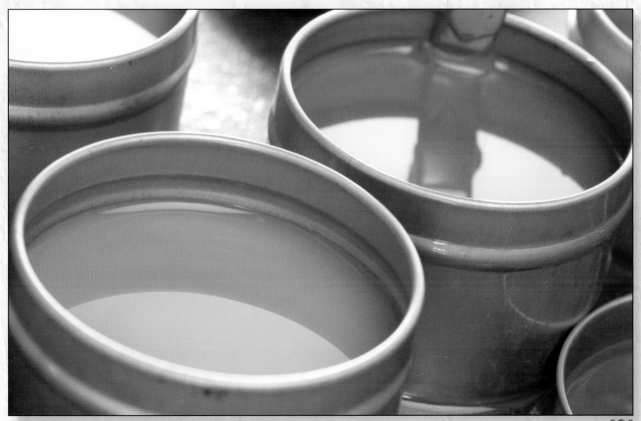

APPENDIX III: DISPLAYING PAPER SUPPORTS

UNFRAMED FLOATING SUPPORT

One of the reasons I began working with handmade paper supports is that the canvas can be displayed without framing. Today, with the newer floater frames, I often display my work framed, especially if I am wrapping the paper. Choose the presentation that best suits your work.

1 If you are going to display your work unframed, make sure the entire surface of the support is covered in paper. If you are not embedding the support, you will need to glue an additional sheet of wet paper on the back of the panel. Do this by making an extra sheet of paper the size of the paper you are going to wrap. Tear the wet paper to get it approximately the size of your support. Use methylcellulose to glue the second sheet to the back.

2 Purchase an inexpensive artist's painting canvas one standard size smaller than your paper support. (If the support you created is 12"×12" [30cm × 30cm], purchase a canvas that is 10" ×10" [25cm × 25cm]. If your support is 11" ×14" [28cm × 36cm],then purchase a canvas that is 9"×12" [23cm × 30cm]). Using a palette knife, spread an even layer of heavy gel medium over the entire canvas.

3 Center the canvas over your support and glue it down, making sure there is good contact over the entire surface. Add weight to the canvas and support, and allow it to dry overnight. Add framing hardware to the inside of the canvas panel.

Unframed Floating Support

Displaying your art in this manner will cause the artwork to "float" off the wall while hanging flat.

CUSTOM FLOATER FRAME SUPPORT

The advantage of custom framing is that you can have several made the same size. This is often a cost-saving measure. If you work in 12"×12" (30cm × 30cm), for example, and have fifteen of these frames made, you can purchase the artist's canvases in bulk as well. The greatest advantage, though, is the fact that you can change out work easily and sell work with both a framed and unframed price. With the artist's canvas, the work is still ready to hang.

1 If you want to frame the work and have someone who can make you a simple frame, have them build a wooden shadow box that is 1¼" (31mm) deeper than your support. Select an inexpensive artist canvas panel as you did in the unframed floating support project. Measure the inside dimensions of the canvas panel (the hole made by the stretcher bars). Have the framer cut a hole that size in the center of the back panel of the shadow box.

2 It is not necessary with this process to add a backing of paper because the back of the art will be shielded from view. I usually finish my work with a sheet of paper because I find that the shrinkage is even during the drying process, and the work looks more complete.

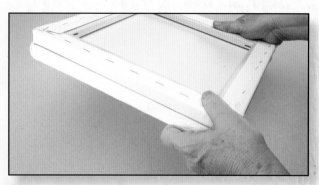

3 Glue the artist's painting canvas to the back of your work as you did in the unframed floating support project. Weigh it down and allow it to dry completely.

4 Line up the opening of the canvas to the opening of the frame and secure the two together with screws. Add hanging hardware to the inside of the canvas panel.

Custom Floater Frame Support

A custom support will cause the artwork to "float" within the confines of a box while hanging flat against a wall.

Commercial Floater Frames

You can find a few inexpensive—but quality—commercial floater frames on the market. These frames are designed for traditional art panels, like Encausticbord, which has a full open back. If your work is on a cradled panel, the mountings are designed to be secured to the inner wood of the panel. If your stabilizer is foam core or gator board, your support cannot be secured in the same way. I find that I can use a commercial floater frame if I get a thin sheet of birch wood cut to the exact size as the frame. For example, if I purchase an 8" × 10" (20cm × 25cm) frame, it is designed for an 8" × 10" (20cm × 25cm) cradled panel. I can use my own 8" × 10" (20cm × 25cm) paper support and glue on the back an 8" × 10" (20cm × 25cm) thin sheet of birch wood. I now have something to which the mounting hardware can attach.

Commercial frames usually come in two depths. When you are designing your supports, make sure you keep in mind the depth of your frame.

RESULTS

 PAPERMAKING

TWINROCKER HANDMADE PAPER
twinrocker.com
info@twinrockerhandmadepaper.com
800-757-8946
papermaking supplies and equipment, handmade paper, fibers and pulp

CARRIAGE HOUSE PAPER
carriagehousepaper.com
info@carriagehousepaper.com
800-669-8781
papermaking supplies and equipment, handmade paper, fibers and pulp

LEE SCOTT MACDONALD, INC.
617-242-2505
catalog only; papermaking supplies and equipment

NASH/RENFROW PRODUCTIONS
papermakingresources.com
cnash@wvcnet.com
520-740-1673
videos, workshops, educational materials

HIROMI PAPER, INC.
store.hiromipaper.com
866-479-2744
handmade paper

INTERNATIONAL ASSOCIATION OF HAND PAPERMAKERS AND PAPER ARTISTS
iapma.info
professional organization

HAND PAPERMAKING
handpapermaking.org
magazine, newsletter, registry

 ENCAUSTIC PAINTING

R&F HANDMADE PAINTS
rfpaints.com
info@rfpaints.com
800-206-8088
encaustic paint, oil sticks, supplies, workshop, artist forum

ENKAUSTIKOS
encausticpaints.com
info@encausticpaints.com
585-263-6930
encaustic paint, supplies, videos

MILES CONRAD ENCAUSTICS
custom-encaustics.com
520-490-8027
encaustic paint, supplies, workshop

EVANS ENCAUSTICS
evansencaustics.com
info@evansencaustics.com
707-996-5840
encaustic paint, supplies

ENCAUSTICSUPPLIES.COM
encausticsupplies.com
muse@museartanddesign.com
503-231-8704
encaustic paint, supplies, books

INTERNATIONAL ENCAUSTIC CONFERENCE
encausticconference.blogspot.com
annual conference founded by Joanne Mattera

INTERNATIONAL ENCAUSTIC ARTISTS
international-encaustic-artists.org
nonprofit professional artists' organization

IEA ENCAUSTICON
encausticon.com
annual members conference opened to both members and nonmembers

ENCAUSTIC ART INSTITUTE
eainm.com
mehrens@eainm.com
505-424-6487
nonprofit encaustic art center

SWANS CANDLES
swanscandles.co
888-848-7926
wax, encaustic supplies

AMPERSAND
ampersandart.com
bords@ampersandart.com
800-822-1939
panels designed for encaustic painting

ENCAUSTIKITS
encaustikits.com
360-239-8081
encaustic paint kits

NORTHWEST ENCAUSTIC
nwencaustic.com
paint, workshops

WAX WORKS WEST
waxworkswest.com
wax supplies, workshops

THE ENCAUSTIC CENTER
waxworkswest.com
books, supplies, workshops

VENT-A-FUME
ventafume.com
877-876-8638
bench-mounted studio ventilators

INDEX

ACKNOWLEDGMENTS AND DEDICATIONS

DEDICATION

- To my husband, Charlie, without whose support and sacrifice I could never have had the freedom to do what I love.

- To all of my students over the years who inspired me to continue to discover new ways to share my enthusiasm for the process of creating.

- To all buyers and collectors of my work: When you take home a piece of art, you complete the circle of creative expression.

ACKNOWLEDGMENTS

I have written numerous plays in my other life as a theater director and drama teacher. However, after leaving the stage, I only wanted to submerse myself in pulp and wax. As life would have it, I find myself in front of the computer again instead of in my studio. They say you can take a teacher out of the classroom, but you can't take the classroom out of a teacher. I like to think that this book is my classroom. I trust that some of the pleasure of what I do in paper and wax can be felt through my words and will send you in search of ways that these two media can transform your own work.

I thank Patricia Seggebruch, who first suggested that I write this book, and Tonia Davenport who believed that it would sell. Thanks to the generous and talented production staff at North Light: Christine Polomsky, who captured the subtle qualities of the wax and paper with her camera, Kristy Conlin, who proclaimed from the outset that writing a book would be fun … and then did all she could to make it so, and Geoff Raker, who could take even the smallest demo piece and make it look amazing.

It's not easy having an artist in the family. I thank my parents, whose creativity was evident in our growing up, and my brothers and sisters, who love me even though they don't often understand what it is I do.

Many fellow artists have mentored me in my career. I want to thank Beck Whitehead for introducing me to the wonderful world of paper and for allowing me to follow my own path with the pulp. Thanks to Carol Mylar, who opened the door to paper as sculpture. Her loving friendship through the years has been so important. Special thanks go to Ed Cruger. Even though his brush makes magic daily, he understands the force that drives one to excellence. I am grateful to be invited into his "mutual affirmation" club. Mostly, thanks to the lovely and talented group of women artists who meet faithfully each month to provide critique and support: Mary Ellen, Linda, Kay, Terry Gay, Mary, Aggie, Ann, Julie and Allison. They have been and continue to be the most significant source of creative challenge in my artistic life.

Finally, to my husband, Charlie, I owe both gratitude and love. He understands and accepts the up and down creative world in which I live, supporting me during the eighteen-hour days of theater production and through the lean years while I searched for my artistic voice. He has celebrated my successes and sustained me in the failures. He has walked through countless galleries, drank cheap wine at openings and spent his vacations tramping through the art district. Someday I WILL make you a kept man!

ABOUT THE AUTHOR

Photo courtesy of: Mehri Rae Dollard

Michelle Belto has been an artist and teacher since 1971. She holds a BA degree in education with teaching certifications in art and theater, and an MA from John F. Kennedy University in California. Her work as a performer, presenter and visual artist spans more than thirty years, three continents and thirteen publications.

Michelle creates her own canvases from handmade paper and then paints on these amazing forms with layers of molten beeswax. Her contemporary paintings sit on the wall like sculpture.

Michelle has exhibited throughout the United States and been a featured performer in numerous national and international venues. She has written and produced several scripts, including *Hildegard of Bingen*, a full-length one-woman play that she performed throughout the United States and Canada. Her visual arts awards include SA Arts Foundation Grant 2009 finalist, Luminaries 2010, and Creative Capital/SA 2008.

Michelle Belto now works full-time as a visual artist and lives in the Texas Hill Country with her husband and a menagerie of furry creatures. *Wax and Paper Workshop* is her first book.

16 15 14 13 12 5 4 3 2 1

DISTRIBUTED IN CANADA BY FRASER DIRECT
100 Armstrong Avenue
Georgetown, ON, Canada L7G 5S4
Tel: (905) 877-4411

DISTRIBUTED IN THE U.K. AND EUROPE BY F&W MEDIA INTERNATIONAL LTD
BRUNEL HOUSE, FORDE CLOSE, NEWTON ABBOT, TQ12 4PU, UK
TEL: (+44) 1626 323200, FAX: (+44) 1626 323319
EMAIL: ENQUIRIES@FWMEDIA.COM

DISTRIBUTED IN AUSTRALIA BY CAPRICORN LINK
P.O. Box 704, S. Windsor NSW, 2756 Australia
Tel: (02) 4577-3555

ISBN-13: 978-1-4403-1704-0

fw media
www.fwmedia.com

metric conversion chart

to convert	to	multiply by
inches	centimeters	2.54
centimeters	inches	0.4
feet	centimeters	30.5
centimeters	feet	0.03
yards	meters	0.9
meters	yards	1.1

Edited by **Kristy Conlin**

Designed by **Geoff Raker**

Production coordinated by **Greg Nock**

Photography by **Christine Polomsky**

INDEPENDENCE TOWNSHIP LIBRARY
6495 CLARKSTON ROAD
CLARKSTON, MI 48346-1501